PRESTON
in the 1960s
Ten Years that Changed a City

K EITH J OHNSON

AMBERLEY

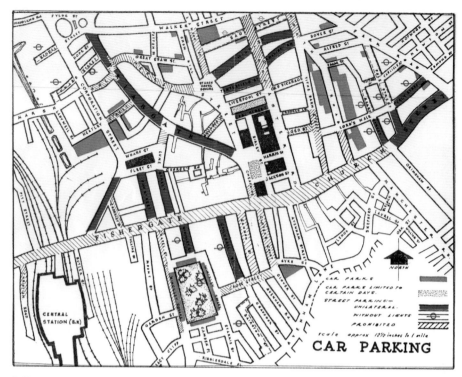

A Preston city centre map of 1964, with car parking becoming a problem and developments underway.

First published 2015

Amberley Publishing
The Hill, Stroud
Gloucestershire, GL5 4EP

www.amberley-books.com

British Library Cataloguing in Publication Data.
A catalogue record for this book is available from the British Library.

ISBN 978 1 4456 4181 2 (print)
ISBN 978 1 4456 4191 1 (ebook)

Typesetting and Origination by Amberley Publishing.
Printed in the UK.

CONTENTS

ACKNOWLEDGEMENTS

I must acknowledge the help given to me by the staff of the Harris Reference Library in Preston, who willingly assisted as I delved into their archives. Their records of the period made my research much easier.

My appreciation also goes to the newspaper reporters of the *Lancashire Evening Post*, who chronicled the events of the decade. Without their accounts this book would not have been possible.

Besides my own collection of images and illustrations, I would like to thank the *Lancashire Evening Post* for permission to use images that are now stored in the Preston Digital Archive. Also my thanks go to Richard H. Parker, the creator of the PDA, for the use of the archive's images.

My thanks also go to Pat Crook for cheerfully checking my text and putting her literary skills at my disposal once again.

ABOUT THE AUTHOR

Keith Johnson is Preston born and bred. His previous works include the bestselling *Chilling True Tales* series of books, which feature Preston, Lancashire and London, and the popular *People of Old Preston*, *Preston Remembered* and *Preston Through Time* books. For over a decade he has contributed numerous feature articles on local history to the *Lancashire Evening Post*, and since 2011 has written a weekly Court Archive for the *Lancashire Evening Post Retro* magazine.

Keith was educated at St Augustine's Boys' School in Preston prior to attending the Harris College, where he gained his qualifications for a career in engineering then spending forty years working for the printing press manufacturer Goss. He spent his teenage years living and working amid the Preston of the 1960s. To reflect on those times is a work of pleasure.

Keith Johnson – a teenager of the times.

INTRODUCTION

Perhaps, like myself, you lived in Preston in the 1960s and look back on the time with fondness. On the other hand, it may be a decade well before your birth and one that only the older generations talk with nostalgia about.

A ten-year period in any town's history covers many things, be they social, industrial or commercial. For Preston, the decade will be recalled for many incidents and accidents, for triumphs and tragedies, for joy and despair, all of which helped shape the Preston of today.

Having shrugged off the toil and torment of the Second World War, the whole country, Preston included, was out to build a better future. New homes were on the agenda; goodbye to outside toilets and tin baths, hello to indoor convenience, a hot bath with bubbles and even a shower. Many cobbled streets were abandoned and endless rows of terraced homes demolished. They survived the Blitz, but not the New Town planners as high-rise flats and maisonettes would become the norm. Green pastures new it seems.

Schools were also changing. The old and decaying church schools made way for the secondary modern and countless advances in reading and arithmetic, plus the odd foreign language thrown in to expand the students' knowledge of the world. The church schools had ensured that religion was at the forefront of the next generation's thoughts, and church and chapel alike thrived with devotional and social activity.

There was a certain amount of prosperity about Preston, with work aplenty for both young and old. Some, like myself, would have started the decade as a newspaper boy, delivering papers and comics morning and night, ending the period having served an apprenticeship, including days and nights at college, in the thriving engineering industry.

It was a decade that saw the world of high street shopping and commerce begin to change. Preston was no exception in that respect, with proprietors of Friargate, Fishergate and Church Street all bowing to progress. Opening for half the day on a Thursday was under threat, although Sunday opening was still a generation away.

On reflection, the decade seems to have started with a monotone appearance and ended in glorious technicolour, much like our television sets. The views had certainly become more panoramic; the building boom that followed the post-war baby boom meant the town of Preston was a city in waiting.

1

WHEN THE
DECADE BEGAN

The Preston of 1960 was one that heralded change, as a new decade began for the 116,000 people that called Preston home. New housing schemes were on the agenda, with flats and maisonettes set to replace the terraced rows being demolished in a vast slum clearance operation. It left large areas of land covered with bulldozed bricks and rubble and a feeling of transition among local folk. The old Victorian town hall in the Market Square was still a blackened ruin following the fire of 1947, and at last it seemed like something would be done about it. New secondary modern schools were seen as the way forward, and many church schools were coming to the end of their days.

A new ring road was also on the agenda, with transport links seen as vital for the town, while the new Preston bypass motorway was proving a success. Town centre traffic was starting to cause problems and talk of pink parking zones was suggested. The Preston Corporation buses still collected passengers from the numerous bus shelters around town, and the Ribble buses were a familiar sight at their Tithebarn Street bus station. All that was also to change before the decade closed.

The decade began with the Labour Party in control of decision making in the town hall. Over the years that followed, the tussle in the local political arena would be intense. Following the General Election of the previous October, the Conservatives could console themselves with the fact that they held both parliamentary seats, a situation that would be challenged in two mid-decade general elections. Appointed the previous year, Florrie Hoskins began the decade as the Mayor of Preston and was followed by a list of loyal Preston folk who ensured the rites and rituals of office were observed. It was also a period when two long-serving councillors had their names added to the prestigious list of Honorary Freemen of Preston.

High street and market shopping was certainly popular, with many a housewife making a daily trek to the stores for life's essentials due to the lack of fridges and freezers. Shoppers had shopping baskets rather than carrier bags, and in many premises it was a shopkeeper gladly attending to your needs rather than the self-service of today. Change was on the way,

however, with the St George's Shopping Centre soon to be in the planning stage. Fast food was still something of a novelty, generally restricted to fish and chips or a hot potato pie, all neatly wrapped in old newspapers to retain the heat.

The cotton industry had been in decline for quite a while, but the engineering industry was flourishing, with thousands of young people taking up apprenticeships. Preston Docks also played a significant part, with reports of a record tonnage passing through the port.

Preston fire brigade would begin the decade at their Tithebarn Street site, but change was in the air. There were plenty of fires to keep them busy, besides those built yearly on the streets on 5 November.

Preston still had its own police force with a chief constable, but that would change. Crime was a daily reality, and the magistrates and judges were kept busy. Sadly, it seems that some had murder in mind and the extremes of the law would be enforced. Preston Prison was once more a useful institution after decades of decline, and over 700 prisoners were kept within its walls.

Churches and chapels of all denominations seemed to be enjoying a heyday with congregations filled with enthusiastic worshippers. The Roman Catholics, the Church of England and the Methodists all went their separate ways, but united in progress. The many vicars, priests and parsons would stamp their mark on the life of Preston. Some decaying church buildings were under threat, while new churches were in the pipeline. The dearly departed were still being buried at Preston Cemetery on the outskirts of town, but an alternative option was about to be offered.

Television sets had become the norm in most households, although generally they were only rented and the pictures were in black and white. Cinemas had started to see a decline in audiences, although Preston still had a number of town centre auditoriums for the film fans. Bingo halls and betting shops would begin to take their place as leisure activities. They were also the days of teenage dreamers who wanted to look fashionable; there were record shops stocked with hit parade vinyl records, coffee bars, discotheques and youth clubs, and mods and rockers.

The more mature liked to take to the dance floor of the ballrooms or enjoyed a visit to the theatre. Public houses were as popular as ever, although some of the older inns and many of those on terraced street corners were being swept away in the name of progress.

Traditional festive occasions were enjoyed by all, with Christmas, Easter and Whitsuntide all having their unique and enjoyable pastimes, while Wakes weeks left the town deserted as workers flocked to the seaside.

Amateur footballers were happy to be kicking a ball in the parks on a Saturday afternoon in the winter; come summer they donned their whites and played cricket. The many bowling greens had players on them during both the day and evening. Swimmers made the most out of the open-air swimming pools in the summer, as well as the Saul Street baths, which youngsters regularly

visited on school trips. Many cyclists got their exercise on the ride to work, and for many a stroll in the park or the odd rambling day was all they desired.

As for Preston North End, it was a decade of ups and downs. They started the period in the top flight of the Football League, but the retirement of the legendary Tom Finney began a decline in the club's fortunes. Nonetheless, they had their moments of glory, particularly in the FA Cup. Throughout the decade, the 'Last Football' post kept you up to date. For the spectators there was also greyhound racing to enjoy, professional wrestling and boxing drew many a crowd and the Preston cricketers challenged everyone down at West Cliff.

Proud Preston was in quite good shape as the decade began, and it had become a better and wiser place when it ended. A ten-year period of toil, tension, torment and triumph to build the Preston of the future. Of course by then man had landed on the moon – can you believe it?

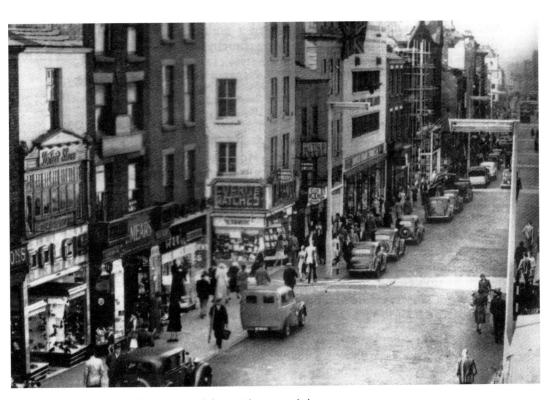

Fishergate 1962. A busy thoroughfare with cars and shoppers.

Those Pounds, Shilling and Pence Days

Back in 1960, we still talked of pounds, shillings and pence; throughout this book you will see reference to the cost of various things. Like myself, you may be curious as to the present-day values. Hopefully these examples will assist in comparing.

The calculation of inflation using the Retail Price Index reveals that from 1960 to 1970 the rate of inflation was 48.91 per cent, and from 1960 to 2012 the rate of inflation was 1,852 per cent.

When Tom Finney finished playing for PNE in 1960, the maximum wage for footballers was £20 per week. The equivalent of £402 per week today.

The booming Preston Docks reported a turnover of £1 million in 1960 – that is £20 million in today's reckoning.

When PNE signed Alfie Biggs from Bristol Rovers in 1961 he cost £18,000 – equivalent to £350,000 today.

The three blocks of high-rise flats built on Moor Lane in 1962 had cost just over £1 million, equivalent to over £53 million.

The Great Train Robbery of August 1963 was reported to have been worth £2.5 million to the thieves. Today that haul is calculated to be £45.7 million.

A ticket to see the Beatles at the public hall in 1963 was a bargain 4s 6d, today's relative value being £4.10.

On the opening night of the Empire Bingo in 1964, prize money of £300 was there to be won. Eyes down for a full house which would now equate to £5,300.

In 1965, the landlord of the Greyhound Hotel was awarded £2,000 in compensation after the tragedy that killed his wife – today's value being £33,000.

A newly built three bedroom house on Black Bull Lane in 1967 would cost you £3,200 – just over £50,000 today.

The British Home Stores premises on Fishergate were redeveloped in 1967 footing a bill of £500,000 – that's £7.9 million in today's money.

In 1968, St Joseph's opened their new youth centre, which had cost £30,000 – a current value of £454,000.

In 1969, local agricultural workers campaigned for £16 per week – they were asking for the equivalent of £230 as man landed on the moon. Rhubarb on that day was sold for 1s per pound – or 72p in today's money. A Preston guy who backed man to land on the moon that year and won £10,000 had scooped the equivalent of £143,000. The bookmaker William Hill was stung by that one. Of course, it's not all about the money after all – or is it?

2

LOFTY AMBITIONS FOR PRESTON'S FUTURE

In the middle of the decade, bulldozers roared and buildings came crashing down as old dwellings were reduced to a heap of rubble. A new town was rising from the ashes of old Preston, but local folk saw the devastation as ugly, unhealthy and uninviting. The town planners had formulated their ideas and were pressing on regardless. Visitors to Preston found it quite appalling, but it was deemed a necessity for progress. By September 1966, the most active assaults were being made at each side of Lancaster Road, north of the covered market. South of Walker Street, the clearance was being done for the inner ring road, a priority high on the planners' agenda, while land north of Walker Street was earmarked for a new housing area. The contractors who were engaged in the demolition work had been stockpiling, and at the corner of Saul Street and Lancaster Road there were old washing machines, old mattresses, rotting furniture and floor coverings that left a distasteful odour in the air. In truth, demolition and rebuilding had already been going on at quite a pace for ten years, but now it was at the very heart of the town.

At the dawn of the decade, the old pre-fabricated dwellings at Ribbleton were in the process of closing down, new flats had become occupied in Samuel Street off New Hall Lane, and the apartments in the Avenham area on Brunswick Street were in construction. Soon, tenants would be occupying the new skyscraper blocks of Lancaster House and York House, built at a cost of £130,000 and standing eleven storeys high. Their appearance on the skyline caused quite a stir, but they are no longer with us, having been knocked down in 2005 and replaced by lower level city view apartments.

Back in 1961, the bulldozers had been busy on the last phase of clearance at the heart of the Avenham area, with the few remaining residents in the clearance zone listening to the crash of masonry and the hammers of the demolition contractors. The skyscraper buildings of Carlisle House, Lincoln House and Richmond House either side of Avenham Lane, would soon follow, standing twelve storeys high and 35 metres tall.

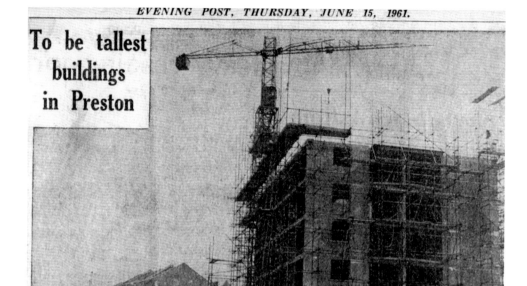

EVENING POST, THURSDAY, JUNE 15, 1961.

To be tallest buildings in Preston

RISING from the site of 460 demolished houses off Moor-lane, Preston, is this skyscraper block—one of three 16-storey buildings, which together will provide homes for 435 families.

By June 1961, the construction was well underway on the three new skyscrapers on the Moor Lane clearance area. A project costing over £1 million, the sixteen-storey high blocks became the tallest buildings in town.

In February 1962, as Preston's fire-damaged town hall was being demolished, the borough engineer and surveyor, Mr E. H. Stazicker, spoke of more sweeping changes in the years ahead. A bigger and brighter Preston was his vision, with the old tired public hall, the old King's Palace in Tithebarn Street, and the properties in Bamber's Yard all being demolished to give room for the modern Preston.

By June 1962, the finishing touches were being put to Cumberland House – the first of the three multistorey blocks of flats being built by Preston Corporation on Moor Lane. Cumberland House and its neighbours, Westmorland House and Northumberland House, were structures standing 51 metres tall, each block containing ninety-six apartments. Unfortunately, they had a relatively short lifespan, being demolished with controlled explosives at the dawn of the twenty-first century after being condemned as dangerous with spalling brickwork and problems within the concrete structure. Ironically, the bill for demolition of £1.4 million was more than the price of construction.

A report published by the Ministry of Housing in February 1963 revealed that 5,688 dwellings had been constructed in the town since the Second

World War, with 4,828 being constructed by Preston Corporation. From 1955 onwards, over 2,000 unsuitable properties had been demolished. In September 1963, the new flats and maisonettes in the Avenham redevelopment area were starting to fill up with council tenants. To many, the ultra-modern maisonettes seemed a world away from their previous century-old terraced homes. Luxury abounded, with gas central heating, fitted kitchens and air conditioning, and all for 62s per week. Nonetheless, some described them as monstrosities, but the Ministry of Housing thought otherwise and gave them a design award.

In January 1964, the new housing development at Ingol was in the news. It was confirmed that Ingol was on track to become Preston Corporation's biggest estate. Since March 1962, several hundred houses, maisonettes and bungalows had been completed; the plan was to complete the development of 200 acres of farmland to eventually become the site of over 2,500 homes. They were said to be a town planner's dream, incorporating play areas for children and landscaped gardens.

The revolutionary changes to the Avenham area were still going on mid-decade, and in June 1965 the completion of two tower blocks, Kendal House and Penrith House, on Avenham Lane, led to an official opening. With nineteen storeys and standing at 53 metres, the new structures demonstrated the policy of high-rise living, and there were plans to press on with the construction of three- and four-storey terraces of maisonettes in the vicinity of the towers. The tower blocks cost £800,000 to build, and praise was given to the architects of Building Design Partnership and the builders John Turner & Sons, both local companies. The twin towers are now known as Sandown Court, and they had a £3 million facelift in recent years.

Eventually, in March 1968, the Preston Corporation were able to celebrate the erection of council house number 10,000, after forty-seven years of home building. The honour was shared by a block of eight flats opened on the Queen Street development off London Road.

That year, North Road was very much the focal point of redevelopment, with demolition sites scattered along both flanks and many terraced rows and six public houses reduced to rubble. The road itself was being upgraded and made into a dual carriageway, and there was much amazement at the speed at which new homes were being built.

A *Lancashire Evening Post* article headed 'Instant Homes For Preston' explained that a new technique by Quikbuild Homes of Eastbourne had seen the first three of a planned 180 homes built over a twelve-month contract. Lorry loads of pre-fabricated units arrived in the town, with panels already equipped with doors and windows, and a T-beam roof and floors added in a matter of hours. Yes, you can build a home in a day if you start at the crack of dawn, was the builder's claim.

Besides those who carried on the family tradition of living in council owned property, there was also an increased interest, particularly among young people, of investing in a home of their own. Despite the burden of

THREE NEW SKYSCRAPERS FOR TOWN

THREE new skyscrapers which when completed in September, 1962, will be the tallest buildings in Preston and higher than the Harris Library, are rising from a site off Moor-lane, where previously there were 40 houses.

Costing well over a million pounds, they are 16-storey blocks of flats. Blackpool Tower will be easily seen from the 16th floor.

Down into the deep foundations of these skyscrapers, 135 workmen have poured 200 tons of reinforced concrete. Now 200,000 bricks are arriving on the site each week.

GREAT PROGRESS

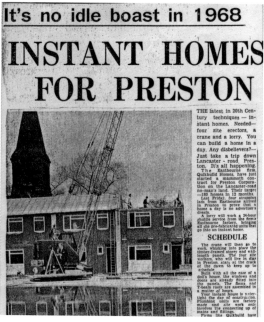

It's no idle boast in 1968

INSTANT HOMES FOR PRESTON

THE latest in 20th Century techniques — instant homes. Needed—four site erectors, a crane and a lorry. You can build a home in a day. Any disbelievers?—Just take a trip down Lancaster - road, Preston. It's all happening.

The Eastbourne firm, Quikbuild Homes, have just started a mammoth contract for Preston Corporation on the Lancaster-road no-man's land. Their target—180 homes in 12 months.

Last Friday, four struggling lads from Eastbourne arrived in Preston to prove that a home a day is no advertiser's dream.

A lorry will work a 24-hour shuttle service from the firm's Eastbourne factory, bringing all the pre-fabricated units that go into an instant home.

SCHEDULE

The crane will then go to work, whisking into place the timber-framed storey and wall-length panels. The four site workers, who will live in digs in Preston, start as the crack of the dawn to keep up to schedule.

Built with all the ease of a doll's house, the windows and doors are already fitted into the panels. The floors and T-beam roofs are assembled in a matter of hours.

Your instant house is water-tight the day of construction. Plumbing units are factory-made and site work only involves the connecting up of mains and fittings.

Firms like Quikbuild have

Newspaper clippings reporting the building boom in Preston.

mortgage payments, homes were being purchased by many who were eager to get on the property ladder. There were many terraced houses up for sale; in July 1967, the town's estate agents were offering a three bedroom house on Waterloo Terrace for £1,400 and another in Delaware Street for £975. Prime location detached houses or semi-detached houses in Fulwood and Ashton were also available for upwards of £3,300. The main attraction for many though were the new estates that were emerging, such as the Wimpey Homes being built off Black Bull Lane in Fulwood. An ultra-modern three bedroom house could be bought for £3,200, with a £50 deposit securing your dream. It was a similar price if you fancied one of the twenty-two semi-detached chalet bungalows being built off Tag Lane in Ingol. If you could afford to pay a bit more, then off Sandygate Lane, Broughton, you could have a bungalow for £3,850 with oil-fired central heating.

The building that must be regarded as the most controversial of the decade was Crystal House, built on the site of the former town hall that had been cherished by all. The town hall had been vacated by the town council with their move to the Municipal Buildings on Lancaster Road, and the last function took place in August 1961, when over 300 people attended a coffee evening and fashion parade organised by St Joseph's.

Within months, the demolition men moved in and started knocking down the 1867 Gothic building that had been lingering since 1947, when it had been gutted by fire. Souvenir hunters had an early opportunity to get their hands on town hall treasures when a local auctioneer held a sale of 100 lots

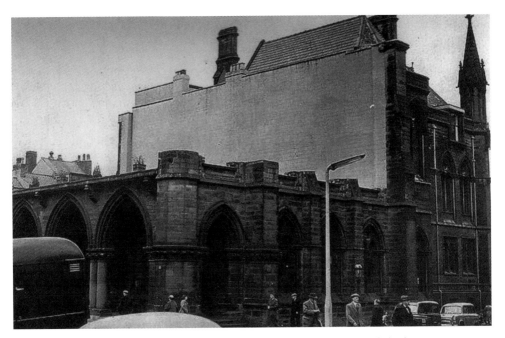

The remains of the fire-ravaged Gothic town hall were about to be demolished.

of fixtures and fittings, such as brass door handles, doorknobs and brass balls from banister rails. Crystal House was built on the site at a cost of £500,000, and was a structure designed for shops and offices. Unfortunately, take up was slow, and by 1965, only two shops and a suite of offices had been occupied. It was looked upon with dismay, and was thought of as an architectural outrage and a huge eyesore by many.

Things were also moving on in the education system. The town had significant historical schools with excellent reputations, such as the Grammar School and the Park School on Moor Park Avenue, and the Convent Secondary School and Preston Catholic College both on Winckley Square. Another cherished school for girls, the Lark Hill Convent (a direct grant grammar school), was moving towards its centenary in a positive manner, having spent £60,000 on classroom extensions and having over 540 girls of all ages studying there.

At the start of the 1960s, the Roman Catholics had a dozen schools in the town and it was quite usual for their boys and girls to be taught through the infant, junior and senior levels in the same building. Among them were St Augustine's, St Walburge's English Martyrs, Sacred Heart, St Gregory and St Joseph's; a number had separate schools for boys and girls.

Likewise, there were many Church of England and state schools still educating from infant upwards. St Saviour's, St Thomas, St Andrew's, Emmanuel and St Matthews were among those with a history for teaching. The Methodists were also still providing education for their youngsters at established schools such as Moor Park Methodists, Ribbleton Avenue Methodists and Ashton

Methodists. In the coming years, the education of older children would be taken over by the fast emerging secondary schools.

During the summer of 1965, a chunk of old Preston was being crushed by the demolition hammer in Cross Street, as the 124-year-old Preston Grammar School building with its ornate pillars was reduced to rubble. The schoolboys had moved on to their Moor Park site in 1914, and the GPO engineering staff moved in, staying until 1960.

By the autumn of 1965 the town could boast that they had eight secondary schools in operation following the opening of the Roman Catholic schools of St Thomas More and St John Fisher.

The first to open had been Ashton County Secondary School in September 1957, followed by the Blessed John Southworth School in the following January. In September 1964, two further schools had opened with Tulketh County Secondary and William Temple opening their doors to pupils. Both had the capacity for 720 students, and among the initial intake were pupils from the closed Trinity School. An annual budget of £2.1 million had been necessary to improve the education facilities. In the post-war era, eighteen outdated schools had been closed and thirteen new schools had been built.

It was also a decade that saw significant development of the Harris College of Further Education, primarily a technical college with a School of Art. It catered for full-time and part-time students, many who were apprentices in industry and attended evening classes. With land available due to the termination of the canal that ran to its rear, they took advantage of the space to erect new buildings. Significant development took place there from 1960 to 1963, the completed facelift costing over £650,000. Education standards were rising, and there was talk of achieving teaching to degree standards, with Polytechnic status the aim.

When the Preston schools reopened after the summer holidays in 1969, a new academic institution came into being. A formal merger of the boy's Grammar School and the girl's Park school created a sixth form college. The first principal of the new college was Miss Muriel Shanks, who had been head of the Park School since 1955.

Significant developments also took place in other areas. Concerns about the treatment of the deceased led to the investment of £70,000 to create a crematorium at Red Scar, which opened in late January 1962. The task of officially opening the new building, set in woodlands, was carried out by the Mayor of Preston, Fred Irvine.

With progress vital to Preston's future, other prominent buildings appeared on the landscape during the decade.

On Guildhall Street in March 1961, work was almost complete on the Guildhall Offices, the future home of several Preston Corporation departments that would be forced to vacate the doomed town hall. At a cost of £120,000, the four-storey building had taken two years to construct. The ground floor became the home of the registrars of births and deaths; the first floor was occupied by the

housing department; the second floor housed the children's department offices and the top floor was for the Preston & District Water Board.

In July 1961, four new wards were unveiled at Whittingham Hospital, built at a cost of £83,000 after a two year long transformation of the St John's block. The hospital provided a caring approach to mental health issues, with 2,600 patients receiving treatment.

By January 1962, work was well advanced on the erection of the new electricity headquarters in Hartington Road. With space for 300 people, the NWEB employees located around the town would be accommodated in the four-storey building.

In October 1963, the new Preston GPO postal sorting office was opened in West Cliff. The building had taken four years to construct and was a new concept in sorting office design, costing £500,000 to complete. Fittingly, the Mayor of Preston – Cllr Cyril Molyneux – who was also a postman, performed the opening ceremony where 500 of his colleagues would work. In September 1967 it was announced that Preston was to be one of the pioneering places that would introduce the new postcode system. Give your mail a PR1 or PR2 identification and the sorting machines could handle 20,000 letters an hour.

The new Telephone Exchange building on Moor Lane was opened in June 1964 by the Mayor of Preston Cllr Joseph Lund, and provided subscriber trunk dialling to exchanges nationwide. The building, positioned close to the Moor Lane tower blocks, had twelve storeys, was 48 metres tall and did not look out of place. It had cost £775,000 to build and fifty telephonists were still needed to work the manual switchboards.

By the middle of the decade there had been moves to improve the health facilities of the town. To this end, a new nurses' home had been built at Sharoe Green Hospital that was capable of accommodating forty-seven nurses. Added to this, new ward blocks, operating theatres, nurse training centres and sterile supply departments were all just twelve months away from completion. All this was to ease the pressure on the Preston Royal Infirmary on Deepdale Road.

In late 1968, the new four-storey office block for National Insurance, overlooking the double Fylde Road roundabout, was opened as part of the Ministry of Social Security. Once again, the necessity for extra office space was being catered for. The reality that more than 20,500 people were working in the town centre by the end of the decade, of whom 13,000 were employed in offices, emphasised the need to expand for Preston to prosper.

Throughout the decade, plans to build a new bus station came into fruition. Preston's complex bus and coach facilities had been spread around the town. Starchhouse Square, once the focal point for Dallas, Scout and Viking Motors who provided rural bus services, was swept away by the middle of the decade. Fox Street had provided a terminal for Fishwick Motors buses, and the Ribble bus station in Tithebarn Street was the place to go if you wanted to go further afield with coaches and double-deckers arriving and departing frequently each day. As for Preston Corporation, their fleet of buses had terminals throughout

the town centre – a situation that often led to road congestion and confusion. Always keen to improve things, they had successful trials with single-decker, one-man buses in August 1966, and a month later they began the debate to change the livery colours of the fleet of buses from maroon and cream to blue and white.

Consequently, there was much delight in October 1969 when the new Tithebarn Street bus station opened. The £1 million investment had provided a terminal that had eighty arrival and departure gates that were all clearly numbered, with those on the west side for Preston Corporation and their fleet of ninety-six buses, and those on the east side for Ribble Motors and Fishwick Motors with eight bays provided for coach operators such as Bon Chaunce, Premier and Mercers. With the head offices of the bus operators within the concourse and canteen facilities for the bus crews, the new venture was welcomed. The bus station opened for passengers on Sunday 12 October, and efficiently dealt with its first rush hour the following day. With its multi-storey car park above, it had become the hub of the town's road transport links. Built on the site of the former Everton Gardens, it was described at the time by the well-respected Lord Stokes of Leyland as 'a model of imaginative planning as good as anything in Britain and even in the world'.

As for the railways, Preston railway station had seen significant changes during the decade, beginning with re-roofing a number of platforms. Not least were the changes that came following the controversial Beeching Report. No longer could you catch a train directly to Southport, which had always been a popular day-tripper journey. The axe would eventually fall in the summer of 1964, due

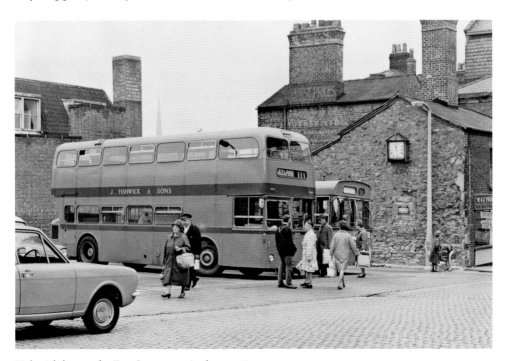

Fishwick bus at the Fox Street terminal *c.* 1968.

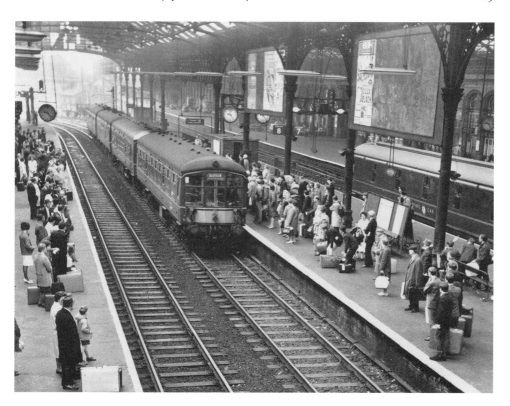

Preston station *c.* 1965 when motive power was changing; the train's destination was Barrow.

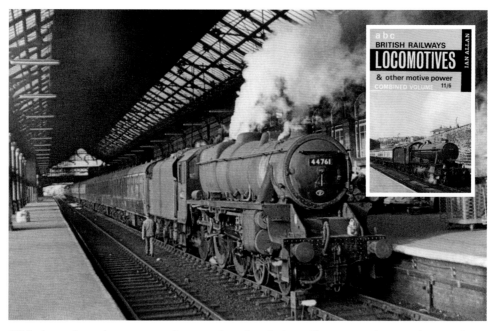

With days of regular steam engines numbered, a Stainer Class 44761 is seen about to leave Preston station in early March 1968.

to low passenger numbers and losses exceeding £120,000. The Preston station still had thirteen operational platforms at the start of the decade, and you could catch a train to stations including Farington, Longton Bridge, Lostock Hall, Midge Hall, Penwortham Cop Lane, New Longton & Hutton; although, mainly due to the Beeching proposals, this would soon change.

It was a decade when steam engines were gradually being taken out of service, much to the despair of trainspotting enthusiasts who had clambered on to the wall at Pitt Street to see the engines steam past. Lucky was the lad who could afford a copy of Ian Allan's *British Railways Locomotive* combined volume, in which he could mark the engines he had spotted. The hobby was becoming so popular that in April 1963 notices saying 'No Train Spotters Allowed' were posted at Preston station. It was claimed they were dashing about from platform to platform and likely to cause an accident. At the time you could only get on the station by purchasing a platform ticket, but it was no deterrent to many. Scores of the spotters travelled into Preston from other locations.

Back in February 1958, rail passengers on the Preston–Blackpool line were able to have a taste of things to come when borrowed diesel unit trains were used to transport them to the seaside. Soon, diesel locomotives would be operating on the London–Glasgow line that sped through Preston, and by July 1973 the electrification of the main rail route was complete. August 1968 saw the last weekend of regular steam working on the British Railway network. Two Lostock Hall crews took out their engines for the last time for trips to Blackpool and Liverpool. The historical journeys were the 8.50 p.m. Preston–Blackpool train and the 9.25 p.m. Preston–Liverpool train. That year saw a number of nostalgic journeys made by steam enthusiasts. The Fleetwood-based engine 'Black' made a trip to Blackpool, with carriages packed with enthusiasts from Preston, and earlier in the year thousands of trainspotters had packed the route from Fleetwood to see the Britannia class engine *Oliver Cromwell* steam past.

For those despairing of ever seeing a steam engine pass through Preston station again, a visit from the legendary *Flying Scotsman* in late October 1968 saw droves of enthusiasts gather on Platform 4 as it arrived from Liverpool, pulling ten coaches packed with 350 passengers on board, heading over the Shap Summit and on to Carlisle, with Preston engine driver Ken Hornby at the controls.

On reflection, the decade had been one of great progress regarding transport links and efficient services, be they on the roads or on the rails. Education was also progressing through a transformation of the facilities of schools and the aims of pupils and scholars. It had also been a ten-year period when Preston, best known for its church spires and factory chimneys, had transformed its skyline with lofty ambitions that had been followed through, with high-rise apartments and tall towers reaching ever higher.

3

INDUSTRIAL LIFE
AND STRIFE

From the start of 1960, Preston was a busy place with a multi-skilled workforce giving the town an industrial edge. The days when the cotton industry accounted for half of the area's jobs were well and truly over. The fact that Horrockses, Crewdson & Co. were merged with Philips of Manchester in 1960 after reporting losses of over £170,000 the previous year, and that in 1962 the Yard Works in Stanley Street would close with 300 job losses, highlighted this reality. Lesser cotton mills would carry on a while longer, and Hawkins were still operating from the Greenbank and Hartford Mills, with an outlet shop in Friargate in 1967, maintaining pride in their homespun products. Sadly, even the hopes for future prosperity at Tulketh Mill failed to materialise. In January 1968, it was announced that the Tulketh Spinning Mill would close with the loss of more than 500 jobs.

Fortunately, the development of Red Scar site by Courtaulds was to help lessen the effect of the decline. Preston had worked hard to secure the enormous investment in the rayon manufacturing plant and, with employees numbering over 3,800, it was a significant industry that had got into full production by 1939 and was thriving. Viscose yarn was the material of the future.

Strand Road was an area that provided employment for Preston folk from early Victorian days when the North of England Carriage & Iron Co. set up their factory on the east side to complement the heavy engineering done on the west side. An early partnership of W. B. Dick and John Kerr had led to a tremendous tram and carriage making business. Dick Kerr's eventually led to the formation of the English Electric Co., and by the 1960s the tram makers had moved on to aircraft. On the west side they were manufacturing locomotives.

In June 1963, the English Electric Co. suffered a slump in orders for British Rail locomotives and 1,000 of the 8,000 employees were thrown out of work. Nonetheless, it was a business that eventually prospered, with a report in 1967 that they had exported £130 million of traction equipment to Africa, Australia, Pakistan and Europe. A business that had produced the famous 'Deltic', which entered service in March 1961, was, by the end of 1969, part of GEC.

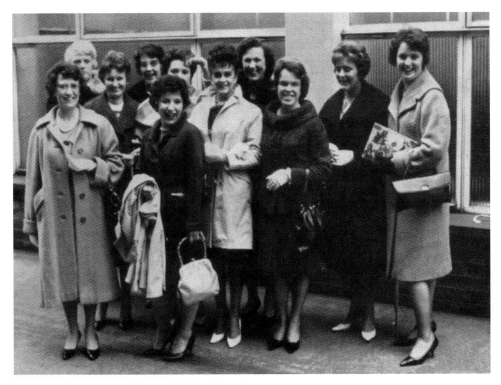

Goss typists and secretaries enjoyed a day out in 1962.

In the middle of the decade, the Preston plane makers, by then part of the British Aircraft Co., became embroiled in the saga of the TSR2, a strike and reconnaissance aircraft developed during the Cold War. The Preston Division at Preston, Warton and Samlesbury employed over 11,000 people on aircraft work, and a decision to scrap the TSR2 project had led to around 2,000 job losses. It was disappointing for the Preston engineers after their success with the Canberra and Lightening aircraft. Fortunately, by March 1966, things were on the up once more after BAC won a £55 million order for Saudi Arabia, and talks were advancing for Anglo-French military projects. Indeed, the head of BAC's business, Sir George Edwards, paid a special tribute to the Preston Division in March 1968 stating that with work on Lightnings, Jet Provost, Phantom and Canberra aircraft, they had achieved £50 million of exports.

On Fylde Road in Preston, the Goss Printing Press Co., having been taken over, were trading under the name of Miehle-Goss-Dexter Limited and were busy producing printing presses for the world. The Preston part of the business had been started by Joseph Foster, and had become Goss Foster in 1936. A new office block and a light machine shop had shown their intentions to progress with their 1,300 employees. In August 1969, the managing director Alex McEwan received the Queen's Award to Industry on behalf of the company, after record exports of over £3 million in the previous year. As the decade came to a close, it was announced that the business had merged with Rockwell International.

On Bow Lane stood the original foundry and offices of Dilworth & Carr, who would become part of United Glass Engineering. New engineering works and offices on Marsh Lane, occupied in 1965, suggested a bright future. With their expertise, they were producing glass-forming machinery and feeders to a buoyant market. Dorman & Smith was another company that was making giant strides in 1960, with pioneering electrical circuits and design. Their Blackpool Road works, opened in 1958, produced electrical gear to be exported across the world.

Other familiar, well-established engineering and electrical companies of the decade included Gregson & Monk, Preston & Fylde Engineering, Preston Precision Engineering, Atherton Brothers, Thomas Blackburn, Messham & Son, Thorn Lighting (trading as Ekco-ensign Ltd), Drydens (with their factory in Grimshaw Street), James Starkie & Sons the wire workers (a fifth generation family business), and Stephen Simpson Ltd, who had specialised in gold thread since 1829.

In 1968, the firm of Attwater & Sons in Hopwood Street celebrated their centenary and made a presentation to eighteen employees who had been with them for over twenty-five years. A pioneering firm in the manufacture of insulating materials they continued to prosper.

Another business that had good times in the first half of the decade was the pioneering three-wheeled motor vehicle designer, Lawrence Bond. With low level road tax and petrol efficiency, the Bond Mini Car prospered, with over 100 a week being produced on double shifts, eventually taken over by Sharps Commercial who manufactured a range of cars and scooters in Ribbleton. Developments even led to a four wheel Bond Equippe, built at their other factory in India Mill on New Hall Lane. This car was powered by a Triumph engine and had a fibreglass body. In 1969, the Bond works were sold to Reliant Motors, another notable producer of three-wheel vehicles. Unfortunately, it was the beginning of the end of the Preston motor manufacturers, because within twelve months Reliant announced the intended closure of the Preston sites with the loss of almost 200 jobs.

When it came to the employment of Preston folk, many more worked in the motor industry, being employed by either Atkinson Vehicles at Walton le Dale or by Leyland Motors, both significant employers and vehicle manufacturers in the 1960s. In April 1968, all talk was of the merger of British Leyland with the BMC group – the new organisation having nearly 200,000 workers in the fold. With a new engine factory and brisk trade, the Leyland plant and chief executive, Sir Donald Stokes, had a confident attitude towards the merger. Exports for Leyland, as well as Albion trucks and buses to Africa and America, was cause for optimism. For Atkinson Vehicles it was a decade of progress, as they built over 1,000 units in 1961 and, confident of the popularity of their vehicles, production increased steadily each year. As the decade closed, they were the target for takeovers and ended up as part of Seddon-Atkinson.

Left: The Port of Preston was an attractive location.

Below: Preston Dock in 1960 was a busy place.

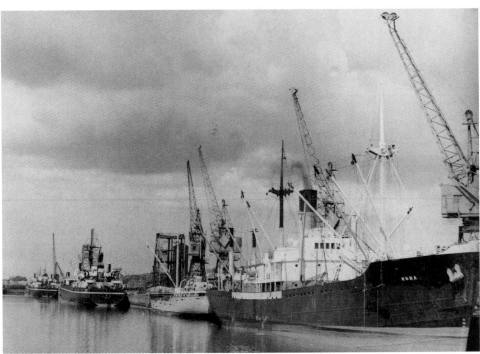

The Port of Preston was certainly prospering, with traffic revenue for the year ending in 1961 exceeding £1 million for the first time ever. The import tonnage had doubled in a decade, with wood pulp, timber and china clay being significantly higher. An announcement in July 1961 that a new transport container service would shortly be introduced between Londonderry and Preston was more proof of good days at the docks. Of course, an efficient dredging fleet was an important essential to keep the waterway channel clear to the necessary depth, and that work was continuous.

The Preston Dock activities also played a significant part in the business of other local firms. Chris Miller Ltd provided essential transport services, and with a fleet of mobile cranes they were in high demand. Cravens Homalloy Ltd, with a workshop on Blackpool Road, were proud of their containers built for easy handling from trailer to ship.

The industrial climate of trouble and strife in the 1960s work place was never far away. In late January 1966, the 400 Preston dockers downed tools over a pay claim. The workers stood firm, crippling the dock for seven days, before a compromise was agreed on pay and conditions.

Early in June 1966, the Courtauld's factory was at the centre of a bitter strike, as workers walked out over production disagreements and bonus pay. Some 500 immigrant textile workers were involved in the dispute, and many of the strikers wanted to break away from the Transport & General Workers Union. Malik Khaliq from Bradford, along with local union officials, negotiated a compromise with the employers and a phased return to work was begun mid-month.

Perhaps a day in mid-May 1968 best reflected the ever-present industrial unrest, when a silent day in factories occurred throughout the nation. Closed factory gates were the order of the day as 3 million engineering workers downed tools. In the industrial heart of Preston on Strand Road, the English Electric West Works were completely closed, and over the road at BAC the only signs of life were draughtsmen picketing outside over their six-week-long dispute. At Goss and Atkinson's Vehicles, the story was the same – locked gates and machines lying idle. At Leyland Motors, engineering work had also stopped for the day. During the afternoon, members of the AEU marched through Preston town centre in support of the 180 draughtsmen and technicians locked out from BAC over their pay dispute.

Strike action was certainly not limited to those in industry, with teachers, bus drivers and conductors, railway men and civil servants all prepared to withdraw their labour. In October 1969, it was the turn of the 140 employees of the Preston Corporation cleansing department to go on strike. There was an eerie silence that Monday, with the familiar clanging of the dustbin lids missing on the streets of Preston and rubbish piled up in the town centre. Their action was part of a national campaign for a £20 a week wage.

Overall, industrial Preston had faired quite well, with many folk taking up careers that would last them a life time. Many companies had prospered and the unions had fought hard to ensure a living wage for all.

Where All That Rubbish Went

50,000 dustbins were quite a headache for the town council in 1963, with the people of Preston throwing 160 tons of rubbish away every day. The increase in pre-packed produce meant dustbins were becoming choked with cartons, paper, tins and wrappings. Fortunately, Preston Corporation had the foresight to develop a disposal system that left many a local authority green with envy.

Preston's new scheme was introduced with the ability to sweep away at least 32,000 tons of rubbish a year. The town had been operating a system of burning rubbish at their Argyll Road depot since 1903. But with those facilities no longer suitable, a £150,000 outlay made rubbish dumping something of a military operation combined with science.

Every hour of the day, tons of rubbish arrived at Argyll Road where it was sorted and bulldozed across the transfer station of over 10,000 square feet. Despite the enormous piles of debris at the depot, the air remained remarkably clean, with the rubbish pushed through holes in the floor into giant trucks waiting below.

Boxes and certain types of paper – but not newspapers – were sorted and compressed into wire-bound bales, each earmarked for the paper mills.

All the other rubbish was then sent on a 7-mile journey out to a 600-acre tipping site at Freckleton. The bulk transporters – some with a moving floor discharge system – travelled along newly made roads to the tipping site. It was estimated that it would be 110 years before every inch of the site would be buried under 18 feet of rubbish, eventually leaving the ground level with the river's flood bank.

As for Preston Corporation's former rubbish tip on London Road, that was earmarked for development as an athletic and sports arena.

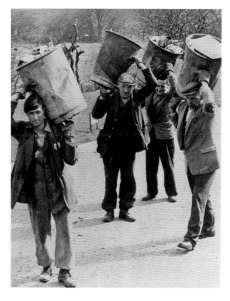

Preston dustbin men in action, *c.* 1968.

4

EASTER EGGS ROLLING ONCE MORE

Easter was celebrated in 1960 over the second weekend of April and, as usual on a traditional Good Friday, many took to the countryside with their packed lunch and a spicy hot cross bun. The numerous local routes such as 'Nickey Nook' and Inglewhite, from the Bruce Clucas book *Forty Rambles*, were as popular as ever and, for those wishing to venture further afield, Alfred Wainwright had just published his fourth book, *The Southern Fells*, for the Lake District hikers. It wasn't the best day weather-wise, being generally cold, blustery and damp. There was much interest in the traffic flowing along the relatively new Preston bypass, the groundbreaking start of the M6 motorway. Kendal and beyond was the destination for many, with a reported 1,800 vehicles an hour heading north at over 40 mph.

From Maundy Thursday onwards, the churches and chapels were busy with priests, preachers and parsons leading the faithful in pray. The message for Easter Sunday, delivered by the Revd Fordham at Emmanuel church, was 'Christ the Lord Is Risen Today', a reminder of what Easter was all about. It was a memorable Easter for the members of the North Road Pentecostal church at the corner of Walker Street, as they opened their doors for the first time, having moved from Cheetham Street to the former Wesleyan chapel.

Easter is always a popular time for brides, with many a happy couple tying the knot. In 1960, the Preston registrar Mr Robson reported that, unusually, not a single couple exchanged their vows on Easter Saturday at the registry office, although on Easter Monday eleven couples were married there. This was well down on the previous year, when thirty couples were wed there. Apparently, the lateness of Easter that year meant that the tax rebate for married couples was not worth the trouble. Among the church weddings that took place on Easter Monday was that of two school teachers, who were wed at St Augustine's church. The bride who carried a bouquet of pink roses wore a white satin gown.

For the footballers of Preston North End there was a packed programme of matches over the Easter holiday. It began on the Saturday, with Deepdale

the venue for the visit of local rivals Blackpool and both sides comfortable mid-table in the First Division. The visitors had played at Everton the previous day, and they took to the field without Stanley Matthews, who had been injured in that match. A bright, sunny afternoon greeted the players with over 26,000 in attendance, many travelling from Blackpool by train. Les Campbell opened the scoring for Preston after a quarter of an hour, Les Dagger made it 2-0 5 minutes later, and then Ray Charnley headed a goal for Blackpool 3 minutes later. Preston were passing and probing, and Tom Finney put them 3-1 ahead just before the interval. David Seddon was having a particularly good match for Preston, and was involved in a number of searching moves in the second half; he found the net within the hour to seal a 4-1 victory for North End.

On a bright and sunny Easter Monday morning, North End welcomed a struggling Leeds United to Deepdale before a crowd of almost 16,000. It was a disappointing game that only came to life in the closing stages. With just 12 minutes remaining, a Finney throw in, a Gordon Milne pass and a stab in from Dave Seddon seemed to have won the match. However, Leeds rallied and with a couple of minutes to go Gibson netted the equaliser.

For many Preston supporters it was a quick dash from Deepdale to Avenham Park, where the egg rolling was in full swing. Among those rolling their eggs on Avenham Park that Easter Monday were the family of joiner Albert Brown. Along with his wife and three children, he took part in the event while reflecting that five years earlier, when he lived in Jamaica, he had never heard of egg rolling. In those days, he had celebrated Easter with a Good Friday

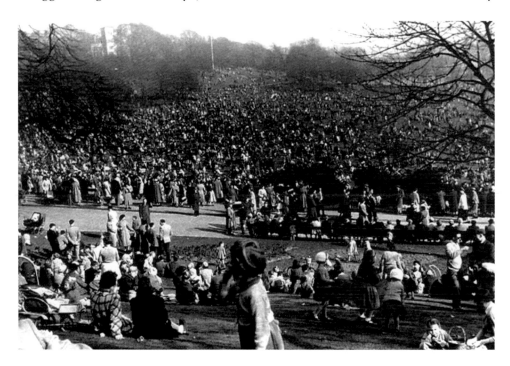

competition to eat a hot cross bun the quickest. Three-year-old Billy Cowell of Moor Lane had arrived at the park early, and devoured all his eggs by lunch time. So, having no eggs left to roll, he hurled himself down the grassy slope. In the afternoon, the crowds were treated to a concert by the Hoggarth's Works Band, a delight for young and old alike.

In true Easter tradition, there was plenty of action at the Preston Greyhound Track, with many of the football supporters from the Saturday afternoon match making for the dog track, where the races began at seven o'clock that night. Eight races followed, and a number of the dogs that had raced on Maundy Thursday were trying their luck again.

Throughout the holiday there had been plenty of dances held, and the public hall ended the break with an Easter Monday special featuring Les Marsden and his band. At the St Ignatius ballroom in Pump Street, with fasting over, they held an 'After Lent' event with the cha-cha, rock and jazz all catered for by the Ken White Group. And, of course, there was dancing at the Preston Jazz Club, the Regent Ballroom and Wally Hobkirk's Dance Club on Lancaster Road.

Despite the arrival of television sets in plenty of Preston homes, the town's cinemas still did plenty of business. They offered panoramic screens, glorious technicolor and double bills. The Empire Theatre on Church Street featured John Wayne in *The Quiet Man*; nearby at the Palladium *Satan's Satellites* was showing and across the street at the Ritz it was Frank Sinatra starring in *Meet Danny Wilson*. The Gaumont had the Walt Disney classic *Sleeping Beauty* topping the bill, and further down Fishergate at the ABC Cinema it was *Inn for Trouble* with Peggy Mount. Only three neighbourhood cinemas remained and they continued with popular films. At the Empress in Eldon Street it was *I'm Alright Jack*, at the Queen's on Acregate Lane they showed the *Lone Ranger* and the *Lost City Of Gold*, while the Carlton on Blackpool Road screened *The Red Beret*.

The Gaumont, ever eager to attract the crowds, went from cinema to live performance for one night only on Easter Sunday. Top of the bill was the American singing sensation Johnny 'Running Bear' Preston and a supporting cast of music makers. Not to be outdone, the public hall weighed in with a concert headed by Paul Robeson on the Wednesday night.

Those who resisted the temptation to venture out for entertainment and stayed by their televisions during the holiday were not disappointed. There were, of course, only the BBC and ITV transmitting programmes. Religious programmes certainly got peak viewing slots with the *Stations of the Cross* and *The Crucifixion* on Good Friday afternoon. For youngsters there was *Watch With Mother* and *Blue Peter* and for family fun *The Army Game* and *Take Your Pick*. Mind you, by midnight after the weather forecast, the stations shut down for the night.

With the improvement in the weather as the holiday season progressed, there was an increase in traffic with many a motorist heading for Blackpool, Morecambe, Southport and Fleetwood. Southport held an

Easter parade and with extra trains from Preston. Sunny Morecambe had hardly a deckchair to spare as folk packed the promenade. Happily, the journey home for most was bereft of the bottlenecks of old, as with the motorway age underway traffic was free flowing.

On Tuesday morning, on the Avenham and Miller Parks, it seemed that the national 'Keep Britain Tidy' campaign was paying dividends. The Parks Department staff commented that although up to 40,000 had been out egg rolling, the litter was only half as much as previously.

Easter wasn't quite over for the footballers, with PNE facing a return match at Leeds on that Tuesday evening. They started brightly enough, and Les Campbell put them ahead netting a Finney cross. However, they paid the price for other missed opportunities when Leeds scored two second-half goals to win 2-1. A vital win for them, but it didn't save them from relegation.

The 1959/60 football season, in which Preston finished in ninth place in the First Division, ended with the retirement of Tom Finney, the greatest ever footballer of Preston North End. His last League game at the end of April 1960 attracted a crowd of over 29,000; an emotional day for Preston which saw them beat Luton Town by 2-0.

Many chose an Easter ramble on routes published by the *Lancashire Evening Post*.

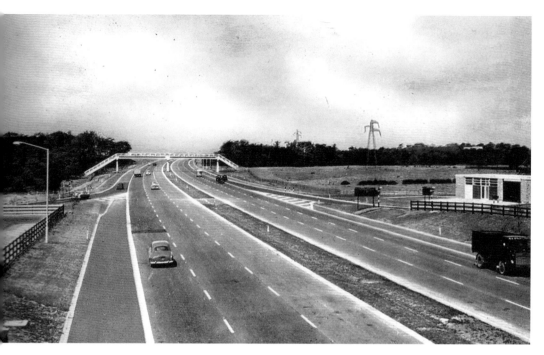

The newly opened M6 motorway. The Preston bypass eased the Easter traffic.

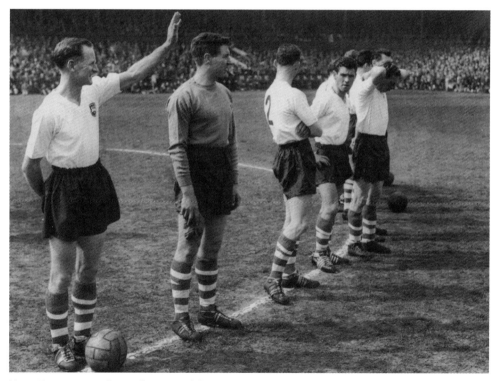

Tom Finney waves farewell at Deepdale.

5

TACKLING CRIME AND CRIMINALS

In the summer of 1964, the debate over the abolition of hanging was at its height, and Preston was to find itself in the national spotlight as two of the town's residents faced execution.

The drama had begun to unfold early in April when John Alan West, aged fifty-three, a van driver for Lakeland Laundry, was found dead in his Workington home. The discovery of his body in the early hours of the morning, which had been bludgeoned and stabbed in the heart, led to a murder hunt. A search of the house revealed a raincoat that did not belong to the victim. In one of the pockets was found a medallion inscribed with the following 'G. O. Evans July 1961'.

The police took little time to trace Gwynne Owen Evans, the owner of the raincoat, to his lodgings in Clarendon Street, Preston. A search of the house led to the discovery of a length of steel-lined tubing, thought to be one of the murder weapons, and the discovery, in the lining of his friend Peter Anthony Allen's jacket, of a gold wristwatch engraved with the name of John Alan West.

Both men were immediately arrested and, under interrogation, blamed each other for the killing. Evans, who had once worked with the victim, claimed that Allen, who had laid the blame on his fellow lodger, had repeatedly hit their victim about the head. There were signs of a terrific struggle, with blood marks suggesting a number of blows being struck from the top to the bottom of the stairs where West was found. Allen stated that Evans had claimed West would be an easy touch and that no violence would be necessary.

The pair had gone to West's home that night to try to borrow money from him, and Allen's wife and children had also gone along for the ride. Mary Allen and her children had remained in the vehicle, which had been stolen two days earlier, while the two men visited West's home. The car had been spotted at Windermere on the way back, and it was there that a police dog discovered the red-handled knife used in the killing.

The two Preston dairymen stood trial at the beginning of July 1964 at Manchester Crown Court, and it lasted seven days. Allen insisted that Evans

had done the stabbing and both continued to claim that the other was the killer. When the jury retired to consider the evidence, they took just over three hours to return a guilty verdict against both men. Mr Justice Ashworth then passed sentence of death on both the accused for the capital murder of the Cumberland man.

With strong feelings for the abolishment of the death penalty, the two condemned men soon had vigorous campaigns going for their reprieve. The Lord Chief Justice who remarked, 'A more brutal murder would be difficult to imagine', dismissed an early appeal against sentence.

Nevertheless, the campaign continued in the three weeks that remained before the date of execution. The curate of Preston parish church led calls for mercy from his pulpit, and he was out on the streets with other campaigners gathering signatures for a petition to the Home Secretary. Over 1,000 names were on the document delivered to the Home Secretary, but he found no reason to intervene. Family and friends then made a plea for clemency to the Queen, but this also was unsuccessful.

On Thursday 13 August 1964, the two men were executed at eight o'clock in the morning. Peter Anthony Allen, aged twenty-one, was hanged at Walton Prison, Liverpool, and at the same time Gwynne Owen Evans, aged twenty-four, was hanged at Strangeways Prison, Manchester.

A silent demonstration took place in their adopted town of Preston, and outside both prisons protestors held vigils as the executions took place.

As things transpired, the two killers were making history, as they were the last to suffer sentence of death, with the bill suspending capital punishment in Great Britain being brought into force in November 1965. Their punishment earned them a place to this day in the Guinness Book of Records, for being the last to feel the hangman's noose around their necks.

 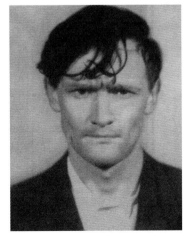

Peter Anthony Allen (*left*) and Gwynne Owen Evans (*right*) – the last men to be hanged for murder.

Crime scenes in the 1960s – the old Farmers Arms where Patrick Coyle was attacked and the Kendal Castle.

Unfortunately, there were a number of other cases of murder or manslaughter in Preston during the decade, including the following.

In late April 1960, Patrick Coyle, aged twenty-nine and of Vauxhall Road, went to a concert at the Farmer's Arms in Market Street, later known as the Jolly Farmer, along with some friends. Also in attendance was Pakistan-born Mohammed Sabar, aged thirty, and three of his friends. One of Coyle's party was a former girlfriend of Sabar, and he started an argument with Coyle and trouble flared. The two groups ended up in a bar brawl with furniture broken, fists flying and a couple of knives involved. Eventually, Coyle was seen to stagger out of the public house, having been knifed in the back and he died shortly afterwards in hospital.

In February 1961, Sabar, and two of his friends Fazal Hussain and Aktair Hussain, appeared at Liverpool Assizes accused of murder. Mohammed Sabar's former girlfriend testified as to seeing him with a studded belt in his hand as he struggled with Coyle, and it was testified that Fazal had taken a knife from his breast pocket as Coyle was overpowered. After a seven-day trial, Fazal Hussain, aged thirty-five, was found guilty of murder and sentenced to life imprisonment. The other two, despite being found not guilty of murder, were remanded in custody to Manchester Assizes accused of the lesser charge of wounding.

In October 1960, the sari-clad body of Savitaben Patel, aged twenty-two, was found in the kitchen of her home on Fylde Road. Twelve stab wounds had

been inflicted, and Karri Vee Reddy, aged thirty-five, who lodged in Latham Street, was accused of her murder. Reddy strongly denied killing Mrs Patel, claiming that while he was in the kitchen he was grabbed by a lodger and attacked by the woman's husband. The jury at Liverpool Assizes thought otherwise, and the Preston cotton spinner was jailed for life.

Late one evening, in July 1961, secretary Edith Connell, aged twenty-five, was sat in her boyfriend's car outside her home in Balcarres Road saying goodnight to him, when a man appeared at the passenger side door of the vehicle holding a shotgun. He then raised the weapon and fired a shot through the closed window, striking Miss Connell in the breast. The gunman then dropped the weapon and fled down the street. Miss Connell was helped into her home by her stunned boyfriend, but before she reached the kitchen of the terraced house she collapsed and died. Within hours, Derek Alan Hill, aged twenty-five, was arrested and charged with the murder of Miss Connell.

Investigations showed that Hill, who once worked at the same firm as the dead woman, had developed an obsession, writing her letters and pestering her even though she had a boyfriend. Hill readily admitted the shooting, but at his trial at Lancaster Assizes in November 1961 the defence argued that he was suffering from schizophrenia. The jury found him guilty of manslaughter on the grounds of diminished responsibility, and Mr Justice Fenton Atkinson sentenced him to life imprisonment, subject to mental health reviews.

On the last Saturday of November 1961, a tattooed man was found dying outside Preston public hall. He was eventually identified as David Marshall, aged forty, a casual worker on Preston Market who lived in North Road. It led to the arrest of William Aston Cragg, aged twenty-four, a machinist from Penwortham who was accused of murder and sent for trial at Lancaster Assizes. The prosecution alleged that Marshall had died after being kicked around the face and head by Cragg outside the public hall. The accused claimed he was provoked by the victim as he tried to enter the premises and that it had ended with a fight that was all over in seconds. After the trial in late January 1962, Cragg walked free, found not guilty of murder or manslaughter before Mr Justice Marshall.

Just before midnight, on a Monday evening in mid-April 1962, a police patrol car was flagged down on Fishergate by Gerald Lancaster Miller, aged twenty-three, who told the police officers that he thought he had killed his wife. Going with Miller to his Starkie Street home, the officers discovered the body of his pregnant wife Josephine Iona Miller, aged eighteen. He told the officers he had hit her with a hammer and then, as she was moaning, he stabbed her. He claimed that anxiety, due to unemployment and the imminent arrival of a child, had led him to kill his wife. At his trial for murder at Lancaster Assizes in late May 1962, his history of mental instability was revealed and Mr Justice Ashworth directed the jury to return a verdict of guilty but insane. He was then sentenced to be detained in Broadmoor, until Her Majesty's Pleasure be known.

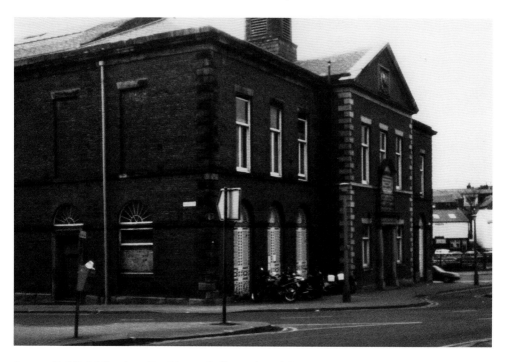

Preston Public Hall, where David Marshall was found dying.

On the last Saturday of May 1962, the landlord of the Kendal Castle public house in Lathom Street went for a day out with some regulars to Thirsk race course. That evening, when the barmaid arrived for work at six o'clock, she found the landlady Mary Salter, aged fifty-eight, lying dead on the kitchen floor in a pool of blood. Some cigarettes had been stolen and money taken from the till behind the bar. Inquiries led to a pub regular, named Bernard McGrorey, who had been spending money freely. It transpired that he had hidden in the toilets at closing time that afternoon, and had attacked Mrs Salter with a hammer when she caught him rifling the till. At the trial of McGrorey, it was claimed in his defence that the killing had not been premeditated and that it should be manslaughter, not murder. The jury took over four hours before returning a verdict of capital murder and McGrorey was sentenced to be hanged. A provisional date was set for his execution, but an appeal was launched and the Lord Chief Justice ruled that a verdict of manslaughter was to be substituted, along with a life sentence for the Kendal Castle killer.

In December 1964, Albert Lee, aged twenty-one, a labourer who lived in nearby Grosvenor Street, Preston, was killed following a stabbing incident in New Hall Lane. He had been out with his younger brother exercising his Alsatian. He was discovered lying in a pool of blood, and died before the ambulance reached the Preston Royal Infirmary. He had stab wounds to the heart and in his back, and had died from a haemorrhage and shock. In February 1964, at Lancaster Assizes, four Pakistanis, three from Churchill

Street in Preston and one from Great Harwood, were accused of murder. There was a confusing testimony over the fight that took place between the deceased, his brother and the four accused, and also as to who had inflicted the fatal stab wounds. According to the defence, the crime had racial undertones and the four claimed that they had been baited, incited and subjected to racial hatred, with the ferocious dog attempting to savage them. After a lengthy trial, the jury cleared all four accused of either murder or manslaughter, but they were found guilty of affray. A week later, they appeared at Carlisle Assizes before Mr Justice Milmo, who told them the evidence had shown that one or more of them had been guilty of homicide, but the evidence before the jury had not been conclusive. He then sentenced each of them to six months' imprisonment and recommended they all be deported upon release.

In mid-October 1965, a Polish man, Josef Potyka, aged fifty-eight and who lived in Roman Road, walked into the Stanley Street police station and told a police officer that two men lay dead at his home. Detective Sergeant Thompson and other officers went immediately to Potyka's house, and found the lifeless bodies of his lodger Sndrezj Groch, aged fifty-five, and Jan Mateja, aged sixty-six, who lived in Penwortham, in a bedroom, with severe injuries to the head and chest.

When he appeared in court, Potyka, a slightly built and balding man, had nothing to say. Deputy Chief Inspector Gerard Jarvis told the hearing that Potyka had told him there had been a big argument, that £200 had gone missing from his bedroom wardrobe and that the three men had fought. When asked why he had attacked the two men with a hammer and a knife, he had told the police he was mad about the missing money. Post-mortem examinations had shown that both men had died from cerebral haemorrhage caused by blows to the head and chest. Potyka was then committed by the Preston magistrates for trial in February 1966 at Lancaster Assizes, accused of the double murder of his Polish compatriots.

The accused, who was to be defended by Preston lawyer Derek Fazackerley, was then remanded in custody and taken to Risley Remand Centre to await his trial. On the opening day of the Lancaster Assizes, it was reported that in mid-January, while in the exercise yard of the prison, Potyka had suddenly collapsed, dying some twenty minutes later from a thrombosis. In view of the unfortunate circumstances Mr Justice Milmo made an order that the indictment should lie on file.

In the first week of March 1967, a late caller to the ironmonger's shop of Brian Sowerbutts, aged forty-three, in Watkins Lane, Lostock Hall, was shocked to discover the proprietor's lifeless body lying in a pool of blood. The manhunt for the killer was ended four days later thanks to the alertness of a Preston policeman, PC Chris Flaherty, who had noted the description of the wanted man from a teleprinter message at Stanley Street police station. Within minutes, as he pushed his rusty old bicycle along Ribbleton Lane, he spotted a man near the Preston Water Board offices who fitted the description of the

murder suspect. Labourer Thomas Duncan Kay, aged thirty, admitted who he was to the constable and was promptly taken into custody.

Kay, of St Mary's Street in Preston, appeared at the Lancaster Assizes in June 1967 and pleaded guilty to the murder. He had made a confession, saying that the shopkeeper had seen him prise open a charity collection box and was about to report him to the police. When he failed to persuade Mr Sowerbutts otherwise, he had struck him with a poker, grabbed him by the throat and strangled him. He had then stolen one of his victim's shirts, because his was bloodstained, and fled the scene after helping himself to money from the till. In his defence, it was stated that he had been drinking prior to the crime and that he was full of remorse for his actions. He was then sentenced to life imprisonment.

He was to spend almost forty years in prison, being released in October 2006. Upon release, he lived the life of a recluse and died alone in a bedsit in Doncaster in 2008.

In April 1969, a significant era in Preston came to end. That month saw the amalgamation of the Preston Borough Police Force with the Lancashire County Constabulary. It meant the end of the role of chief constable of Preston, a position that had been held by a succession of local law enforcement officers ever since 1815.

When Henry Garth retired in 1956, he was replaced by Frank Richardson, who, as things turned out, was to be the last chief constable of Preston. He had spent his early years with the Nottingham City Police, where he soon rose through the ranks.

In 1960, the crime figures were the highest on record, but the borough police force maintained a high proportion of detections and kept the courts very busy. An increase in the number of driving offences led to much longer court sittings. However, the chief constable was happy to report that the installation of traffic

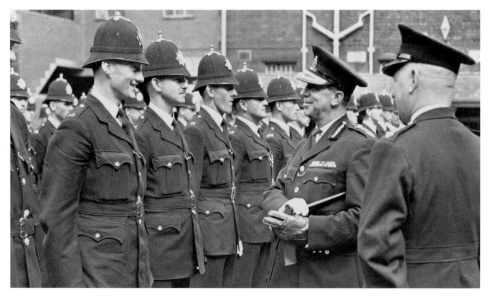

Constables on parade. A Preston Borough Police inspection in 1962.

lights at two important road junctions – Lancaster Road and Church Street – meant that police officers could do more useful work on the beat rather than standing on point duty.

In February 1960, the Preston Borough Police Force had opened a local police station at the junction of Blackpool Road and Pedders Lane. It had replaced the old premises used in Waterloo Road, Ashton. Built at a cost of £4,000, it was to be manned by twenty-four police officers, with the latest telephone communications at the main Earl Street station and the old Stanley Street police station in place. Reflecting the desire of Mr Richardson for more community policing, another local police station was opened in November 1962 on Bow Lane, to serve that area of town. Built at a cost of £5,600, it would become the base for eighteen police officers.

Within two years of his appointment as chief constable, the Preston Constabulary force was 216-strong, including thirteen women. Traffic on the roads had doubled since the war years, and road safety took up an increasing amount of his time. Fourteen fatalities on the roads in 1958 had emphasised the need to improve road safety.

In his crime report for 1963, the chief constable expressed his concerns over the amount of drunkenness in the town. In his opinion, there were far too many local public houses, and he welcomed the news that over thirty of them had been earmarked for demolition in the coming year within the redevelopment areas.

A 1964 county crime report named Preston as one of the most lawless towns in Lancashire, second only to Blackpool. Crime had almost trebled in Preston in a decade, with 3,239 reported incidents compared to a 1954 total of 1,272. It had meant a heavy workload for the detective constables, who each were dealing with over 180 crimes annually.

Besides the normal police officers, the chief constable also had under his command the Preston Borough Special Constabulary, a body of part-timers who willingly gave their time to help with such matters as traffic and crowd control. In 1964, the town had seventy-three Specials who were often seen on duty in the town centre. Teenagers gathering and causing disorder on the streets seemed to be occupying their time that year.

The problem came to a head in late January 1965, when what was dubbed 'The Battle of Church Street' took place, and young Mods and Rockers seemed to earn a reputation for unruly behaviour. It involved a late-night confrontation between 300 teenagers and twenty policemen. It began when a special constable had taken out his notebook while questioning a youth. The resulting fracas blocked Church Street, near to the Top Rank Ballroom, and the screaming, abusive teenagers left three police officers needing hospital treatment. It led to twelve teenagers appearing before the Preston magistrates accused of threatening behaviour. The chief constable, Frank Richardson, gave them a tongue lashing, describing them as young louts. The magistrates thought fit to send three of them to a detention centre for three months, with fines of up to £25 being handed out to the remainder.

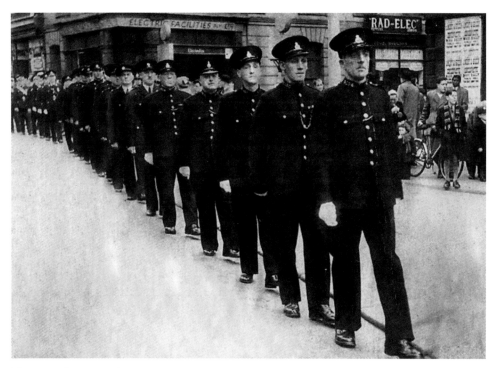

The Specials on parade, *c.* 1960.

Frank Richardson remained at the helm until April 1969, when the merger with the Lancashire County Constabulary took place. Sadly, his time with the county force was short as he died suddenly in August 1969 while on a fortnight's break from his duties.

The merger meant that the chief constable of Lancashire, William Palfrey, was in charge of policing in Preston. In 1965, he had been heavily involved in the increase in mobile policing, with the introduction of the small, blue cars with white doors and stripes, that earned them the nickname the 'Pandas', in the hope that mobile policing would reduce crime. It was really the birth of the 'Z Car' era of policing, and Palfrey became a well-known figure all over Lancashire. Preston itself had a dozen Panda cars by early January 1968, and they worked closely with neighbourhood policemen on the beat. With personal radio communications also established, the police had a new efficiency about them.

6

WHEN SHOPPING BECAME FUN

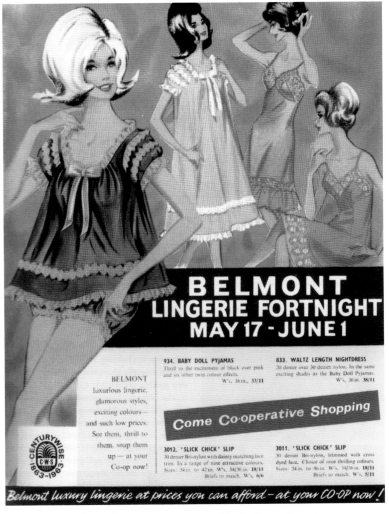

The Co-op celebrated 100 years in 1963 with the latest lingerie.

There is no doubt that shopping has changed in recent decades, and is done differently than in the days of our parents. The traditional corner shops were under threat and the heyday of the outdoor market stall was over, as the emphasis turned to the high street and the days of supermarkets were beginning.

It seems true that back in the 1960s things were already starting to change, although it was still town centre shopping that attracted the investors. In October 1960, the retail giant Owen Owen opened their showcase store on Fishergate. Having been in the town for twenty-three years, they welcomed folk to their new extended premises. It was transformed into a modern rustic brick and glass building, and an invisible curtain of warm air greeted shoppers as they entered. Top fashions for ladies, with autumn coats on offer for £10, pots and pans, blankets and bedding, curtains and cushions and even a television all attracted the crowds. All that, plus a self-service food supermarket and the Red Rose restaurant open for a cup of tea.

In 1961, the opening of the new C&A Modes store on Friargate created much excitement. Locals watched with interest as it was constructed on the site of the old Royal Hippodrome Theatre. A midday opening in March brought traffic to a standstill as a large crowd gathered. It was the firm's thirty-second store in Britain, and marked 120 years since the two Dutch brothers Clemens and August founded the firm.

The new C&A Modes store on Friargate.

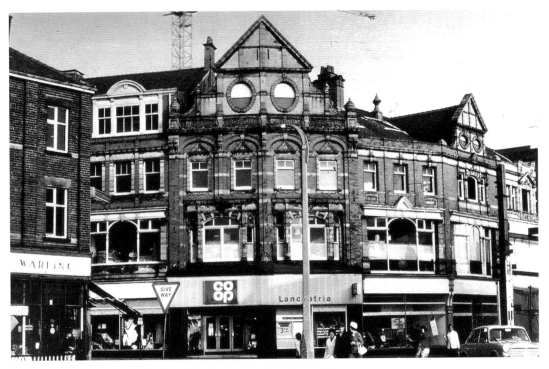

The Preston Co-op displayed the Lancastria logo in 1968.

During the 1960s, a whole generation of schoolchildren were sent to their local Co-op shop clutching a hastily scribbled note to get everyday essentials for their parents. A slab of butter, loaf of bread, packet of tea, bag of potatoes, packet of woodbines, an onion, and don't forget to pick up those dividend stamps. The Co-op branches were all over town, and their flagship premises were on the junction of Lancaster Road and Ormskirk Road. They became known as Fashion Corner, reflecting the extensive clothing departments within. In 1968, the Preston Co-operative Society merged with other nearby towns to form the Lancastria Society, and the decade ended with the new logo displayed on their stores.

The high streets of 1961 were mainly Church Street, Fishergate and Friargate, and many of the stores are locked in the memory bank of local folk. Church Street had the drapers Coupe & Johnson, the gent's outfitters Starkie and Deacon & Hirst, the shoe shop of Turner's, T. C. Hall the sports shop, Cooksons & Sanders the confectioners, Hall's the pet shop, the watchmakers Whittle & Renwick, Cunningham & Forbes sports goods suppliers, butchers aplenty, including T. C. Rainford and Mark Williams, and many more shops of interest including the Northern Rainwear Shop, the National Cash Register Co. and the popular Telehire Ltd shop.

Fishergate was blessed with an abundance of banks, building societies, estate agents and other financial institutions. Mingled among them were numerous stores, many with countrywide reputations, such as the shoe and boot sellers Freeman, Hardy & Willis, Saxone, Dolcis & Barratt, and the

high street retailers Marks & Spencer, Owen and Owen, British Home Stores, Woolworths, Boots, and Timothy White the chemists, Jackson's & Burton's the tailors. Fishergate was also home to E. H. Booths, whose supermarket and café were still very popular. A move in 1961 to self-service at their Fulwood store proved highly successful, and had a knock on effect throughout their chain of stores. A modest looking store was opened at Lane Ends in Ashton in 1962, and this proved popular and profitable.

Friargate was just a few years away from being split into two by the ring road, close to Lune Street. It began the decade with a Home & Colonial Store, a ladies' fashion house called Grafton's, a Betta Modes costumers, a Thomas Yates watchmaker, a Mears Furnishing store, Clemeshas tea and coffee suppliers, H. S. Mosley a supplier of televisions and radios, as well as opticians, dry cleaners, butchers, tobacconists, booksellers including Halewoods, photographers and picture framers, upholsterers and grocers. Not forgetting Lipton's, who had moved into town on Fishergate as long ago as December 1886, claiming to be the largest provision dealers in the world and the store was popular as ever.

Preston's greatest single shopping extravaganza, St George's Shopping Centre, was in the planning stage from 1961 and finally opened, partially, in November 1964. We did have the Miller Arcade still trading as Arndale House, but the new St George's promised so much more.

This had all come at a price. The oft-cherished Bamber's Yard and Anchor Court, areas of narrow cobbled alleys with dingy warehouse buildings, were reduced to rubble, but, most importantly, busy and much-loved antiquated

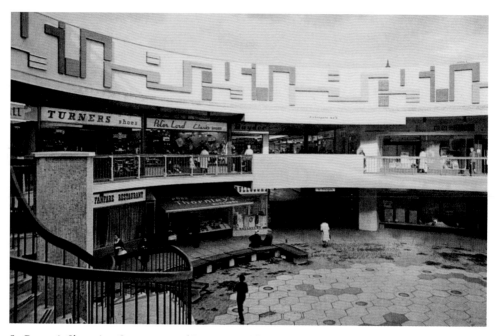

St George's Shopping Centre opened in 1964 amid great excitement.

Above: The arrival of the Kentucky Fried Chicken shop in 1965 created interest.

Right: Coats for boys and men in 1964.

shops. It was goodbye to Parkinson's Carpets, Sutcliffe's the hairdressers, Rhodes the florists, Sharples and their hosiery, Greens the shoe suppliers and Devonshire House of catering fame. Other flourishing businesses, such as leather merchants, plumbers, publishers and upholsterers, had to move on or perish.

The opening-day footfall of 44,000 visitors made the new shopping complex an instant success. Only twenty of the 118 shops were open for business due to unfinished construction, but the curious shoppers flocked to experience this new innovation.

One event from 1965 that is well documented was the opening of the Kentucky Fried Chicken shop on Fishergate by caterer Ron Allen, who had met Col Sanders a couple of years earlier and secured the franchise rights for the UK. Fast food was becoming part of the local scene. Positioned next to a Wimpy Bar and its other neighbour the famous Brucciani café, a delightful place for coffee and ice cream, it would prosper in Preston. Talking of cafés, one destined to remain in the mind of Preston folk was the Kardomah, which was run by John Victor Christian for forty years until his retirement in 1966. Thousands of Preston people popped in for a chat, a cuppa or even lunch through the years.

In early 1967 the British Home Stores premises on Fishergate were temporarily closed for redevelopment, incorporating two adjoining shops and several in Guildhall Street. It would cost them £500,000 to transform their store. When the store reopened in November a false rumour spread that pop idol Tom Jones would reopen it. Sadly he didn't, but hundreds of hopeful teenagers turned up.

No doubt inspired by the impressive St George's Shopping Centre, the planners soon followed up with the beginning of the building of St John's Shopping Centre in 1966, seen as an ideal location to benefit from the new bus station. This included the Fine Fare Supermarket, which became popular from its opening in 1967.

In March 1968, the Gem Super Discount Centre in Dundonald Street, which began life as Fame, announced the completion of the first phase of their development into a one stop shopping centre. Houseware, motor accessories, furniture and newsagents departments all added to their portfolio. An extensive car park and a free bus service increased the temptation to pay a visit.

In the 1960s, the Preston market traders carried on as they had done for decades, but their future would change in the 1970s. The outdoor covered market was still seen as vital, selling fruit, vegetables, cheese, meat, pies, pastries, lace, linen, hats, scarves, ribbons, bows, sweets, chocolates – in fact all of life's essentials. Across the way was the fish market with an outdoor aroma all of its own. Fresh prawns, crabs, smoked kippers, mackerel, cod, haddock, salmon and tuna catered for any fish lover. Standing outside in all weathers, the market folk were sturdy souls.

The arrival of the ring road helped to ease traffic through the centre of town on the high streets and, coupled with the traffic-free shopping centre, gave a more relaxed feeling to the shoppers of the town.

Naturally, the great improvements in Preston shopping did not benefit all. In February 1969, the shop keepers of Friargate, who had seen their premises isolated by the new ring road, were complaining. 'No Parking' signs, reduced casual trade from passers-by and a feeling of being cut off left them suffering badly.

Preston folk had learnt to shop around as the decade came to a close. Gradually, the shopping premises had a feel of luxury about them and shoppers were being tempted to indulge themselves in the latest fashions and fads. The weekly shopping seemed less of a chore and even dutiful husbands were being tempted onto the high street. The options and alternatives had increased and the retailers were keen to get hold of your Preston pennies.

THE BIG FREEZE
OF 1963

Over fifty years ago, the weather served up a winter that lived long in the memory. The winter of 1947 had left the UK shivering, but the winter of 1963 was to be as equally unwelcome. Christmas had arrived with freezing fog, a sprinkling of snow and temperatures below freezing in Preston.

'Arctic Like Weather Grips Britain' proclaimed the *Lancashire Evening Post* headline the day after Boxing Day. A blanket of ice and snow in all places led to chaos on road and rail. A couple of days later, two elderly spinster sisters, Edith and Elsie Catterall who lived in Herschell Street, Preston, were victims of the severe frost. Problems with the gas supply in the area had meant the sisters had kept themselves warm watching television beside an electric fire. Unfortunately, gas was seeping from a fractured main and by the time neighbours were alerted to the danger the sisters had died.

It was the forerunner to a couple of months of trauma and tragedy. Lorries and cars were slipping and sliding on the ice-bound roads, in town and out. Warnings were issued about frozen ponds and lakes, and the frozen Lancaster Canal gave cause for concern. In late January, a man leapt into the canal near Shelley Road to rescue a four-year-old boy who was floating unconscious, face down in a hole in the ice. The hero, Thomas Caton, was alerted to the danger when four youngsters ran down the embankment to tell of the boy's plight.

Another heroic rescue took place in early March, when three young lads pulled an eleven-year-old girl out of Savick Brook. Ian Scott, Stephen Butterfield and John Sanderson had been playing close by when they heard screams coming from the brook and saw the girl struggling for life. Gallantly pulling her out of the icy water, they nursed her until help arrived. Unfortunately, their brave deed was followed by tragedy. Ian Scott, after a change of clothes and a hot lunch by the fireside, left his home in Lea Road on his bicycle. As he approached Leyland Bridge, a car travelling in the same direction knocked him off his bicycle and killed him, before mounting the pavement and hitting another young lad.

At the end of January, there was a temporary respite with the freezing temperatures giving way to a thaw. This was an equally chaotic time, especially

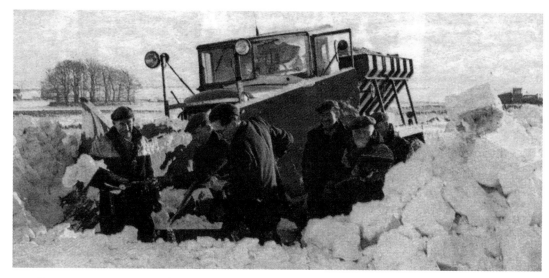

Deep snow was commonplace throughout Lancashire in the 1960s.

when dense fog patches shrouded the highways and byways. On the M6 and A6, visibility was down to yards as traffic crawled along, and a stray donkey added to the motorway chaos near Bamber Bridge. An aeroplane landing at Squires Gate Airport in Blackpool ended up in a field, after encountering dense fog. Thankfully, the nine passengers escaped unscathed.

Early February and it was a case of blizzards again sweeping across the UK. In Preston temperatures plunged to minus 12 degrees, after a day when 4 inches of snow covered our streets. The parks of Preston looked like a winter wonderland and many a snowman appeared in local gardens.

Frosty days on Moor Park.

The freezing weather was back, and then there were the inevitable power blackouts with hospitals and rail services in chaos. In Preston, folk were warned about the rapid deterioration in water supplies. The Preston Water Board producing a chart showing the shortage of water in the reservoirs, with the plea to turn the taps off or go thirsty. 1 million gallons of water was being wasted due to mains pipes bursting, and the water board had already thawed out over 1,000 service pipes. Many an area was without water for days on end, with a bucket parade quite common. Food was also becoming an issue, with cabbages costing 5s each and almost a green vegetable famine to contend with. However, it did lead to a great increase in the sale of tinned vegetables, peas and carrots being most popular.

While it was good weather for skating and sliding, the weather did cause chaos to the racing and football programmes. In that respect, Preston North End did see more action than most. They managed to play Sunderland in their early January FA Cup tie, although a 4-1 defeat on a Deepdale mud bath must have left them wishing it had been postponed. In late February they managed to play a home league match versus Southampton and a 1-0 win, with Doug Holden scoring, making that worthwhile. Two weeks later, Bury were the visitors to Deepdale and they went away with a 2-0 win. Both these matches played before around 10,000 shivering spectators.

The ice age finally turned to spring in early March, and the AA reported that it was like an awakening with 2,000 cars an hour travelling along the Blackpool Road and over 2,000 motorists an hour pouring into

Above left: Frosty forecasts in 1963.

Above right: The North End team of 1963 featured in *Soccer Star* magazine.

Southport to the beach and to Lord Street. So, whatever the coming winters have in store, surely they can't be worse than that endured in 1963.

Birth of the Pools Panel

One significant consequence of the terrible weather was the birth of the football pools panel. These days, the main hope of winning a fortune is a ticket in the National Lottery, but go back fifty years and the hope of riches depended on picking eight draws on the football coupons of Littlewoods, Vernons or Zetters. From Saturday 22 December 1962 until mid-March 1963, the football world was enveloped in the 'Big Freeze' as a winter of Arctic conditions gripped Lancashire and the UK. In Preston, the postponements began on the Saturday before Christmas, when freezing fog led to a late postponement of the PNE fixture at Deepdale. On the last Saturday of the year, things got even worse, with forty-two matches called off, including PNE's trip to Portsmouth.

Perhaps the most significant occurrence was the news that the Pools Promoters Association had cancelled the football pools for that Saturday. On the first Saturday of January 1963, only three of the scheduled thirty-two FA Cup third-round ties were played. Two more weeks of void coupons followed, and then the pools operators, fearing financial meltdown, came up with the novel idea of forming a panel of experts to determine the results of the postponed matches.

Among the first panel was newly retired PNE star Tom Finney, who travelled to London to meet up with ex-referee Arthur Ellis, ex-England striker Tommy Lawton, the ex-Rangers skipper George Young and former Chelsea manager Ted Drake. The panel, rumoured to be on £100 a week, were locked away at the Connaught Rooms in London after being provided with form guides and historical data for the cancelled fixtures. Their task was to determine whether the games were a home or away win, or even a draw. So that when the radio programme Sports Report and television's Grandstand read out the day's scores they had a full list of results. Real results and the panel's deliberations resulted in nine draws and a jackpot of over £22,000 for the last week of January.

It was determined that when over thirty fixtures were postponed, the panel would swing into action. Naturally, the panel's decisions created much debate. When a PNE fixture was involved, Tom Finney took a backseat, lest he should be inclined to favour his beloved North End. PNE's postponed fixture at Middlesbrough was forecast as a home win, and when the game took place in mid-May, the score was 2-0 to Middlesbrough. The following week, a late postponement of the visit of Huddersfield Town to Deepdale was followed by a panel result of an away win. When that match was eventually played in early May, it resulted in a 2-0 victory for North End.

The panel swung into action each week until mid-March, when the thaw set in. The Pools Panel was here to stay.

8

PRESTON GOES TO BLAZES

The Preston Fire Brigade was stationed at their Tithebarn Street premises at the start of the 1960s as they had been since 1852, in premises that had been rebuilt in 1900 and enlarged in 1905. The chief fire officer was Oliver Budd, who had been in control since 1958.

When Oliver Budd arrived in the town in 1945 to join the fire brigade that he would run from 1958 until his retirement in 1971, he was amazed when they received almost 200 calls on his first Bonfire Night in town, with fires on almost every street corner. For all of his firefighting, Oliver Budd was most pleased at the end of his days that he had reduced the number of callouts on Bonfire Night to a handful.

As the fire brigade developed, so did the town's love for Bonfire Night parties, and it became tradition for bonfires to be lit on the cobbles among the terraced streets, with chestnuts roasting, piping hot parched peas and trays of treacle toffee devoured by the mouthful after weeks of gathering wood for the fires. The final act of the night was the burning of the guy, which had spent the last few days in shop doorways as children pleaded for 'a penny for the guy' to get some money for fireworks.

The start of the sixties saw a spate of fires with a huge inferno at the Park Lane Mill in North Road in February 1960, and an October blaze at the Woolworths Store in Fishergate, which brought the town centre to a standstill. However, these were dwarfed by the June blaze at the Locomotive Sheds in Croft Street. The roof was completely destroyed and a dozen locomotives extensively damaged. Two firefighters were injured before the blaze was eventually brought under control. One consequence of the fire was that in August 1961 it was announced that British Railway would be closing the Motive Power Depot at Preston, with the thirty-plus locomotives normally based at Preston being moved to Lostock Hall.

The following year, 1961, was also a busy one, with blazes at the Ribble Paper Mill in Walton le Dale, an Easter fire at Boots Chemist on Cheapside and in June a fierce fire on Preston Docks where a bitumen plant was destroyed. In September, a fire in the Glovers Court area sent flames sweeping through

a three-storey foundry belonging to John Whitehead & Co. One bemused worker who had fled the blaze leaving his jacket behind, returned to the scene later to discover only charred remains of his jacket. Unfortunately, £120 in bank notes and his packet of twenty cigarettes had gone up in smoke.

December 1962 saw the old Roper's Boy's School in Friargate severally damaged in a blaze, which was brought under control from a turntable ladder. Several firemen were injured by flying glass.

March 1965 saw five fire engines rush to Goobys ladies' fashion store in Church Street, next to the Empire Cinema. Despite their efforts, they were unable to save this popular store, which was left a smoke blackened ruin. The drama was witnessed by over 2,000 onlookers as both the Empire bingo palace and the Palladium cinema were evacuated amid fears the blaze might spread; the manager of the Empire telling his patrons they would be given free games the following night.

In November of the same year, the Castle Vernon Bowling Alley, a popular venue for teenagers, was completely destroyed. Flames roared through the fourteen-month-old building and over 100 firefighters tackled the blaze.

A dramatic Clyde Street blaze, in a row of terraced houses in 1967, was dealt with swiftly and efficiently, although one resident fell victim to the fire. Three firemen wearing breathing apparatus had tried to reach the elderly victim in an upstairs room, but were thwarted when the roof collapsed above them, sending them crashing down the stairs of his home.

In May 1968, families were evacuated from their homes as flames swept through a fire lighter factory in Ingot Street, off Wellfield Road. Sixty firemen eventually controlled the blaze in the three-storey structure. Crumbling walls and 50 foot flames made it a difficult task. In October 1968, the Preston Dock estate was the scene of a massive blaze as the Northern Ireland Trailers warehouse was destroyed, along with thousands of bales of Acrilan fibre. With 90-foot flames to battle against, three firemen were treated for heat exhaustion.

Later that October, flames swept through the Tyre & Rubber Services Depot in Brookfield Street. Hundreds of new and used tyres were destroyed in the blaze, and only prompt action by the fire brigade stopped the blaze, engulfing two adjacent terraced homes.

Of course, it was not just fires that the brigade were called out to attend, and in late November 1969 the fire engines rushed to the Fine Fare Supermarket in St John's Shopping Centre after a teatime calamity. With several hundred shoppers in the building, the whole of a ground floor suspended ceiling came crashing down, causing panic. There were anxious moments as police and firemen searched the damaged shop to make sure no one was trapped under the wreckage. The ceiling seemed to crack in the middle and spread outwards as the shoppers screamed, and panic abounded. Altogether thirty-six people, many of them women and children, were rushed to hospital. Fortunately, it was a case of shock and cuts and bruises, but nobody was detained.

No doubt Oliver Budd's days with the Preston Fire Brigade had been

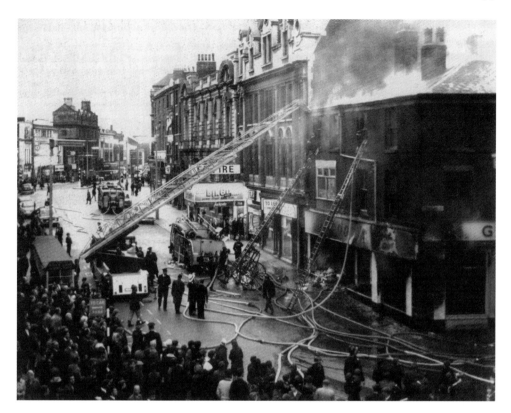

Above: Goobys ladies' fashion store in Church Street ablaze in March 1965.

Right: Fire chief Oliver Budd.

eventful, and he had a lot of memories to look back on when he retired in September 1971. Many a person with their head fast between railings, a ring stuck on their finger, or with their cow trapped in a ditch had reason to be grateful to this firefighter. His time at Preston had seen great advances in fire prevention, and the smooth transition in 1962 from Tithebarn Street to the new fire station on Blackpool Road, which was built at a cost of £154,000. The station had become fully operational on 24 April 1962, and the fire brigade were confident that from the new premises, built on the site of a former clay quarry, they could reach any part of town within minutes. At the official opening, the ladies who were invited to tour the premises wearing stiletto heels were asked to place special heel guards on them to protect the plastic/rubber floor from damage.

On his departure, the Preston fire chief handed over an efficient unit that he was proud of, equipped with a fleet of Dennis fire appliances with Rolls Royce engines.

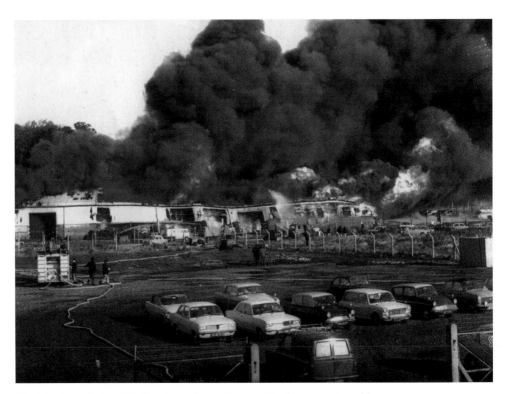

The Northern Ireland Trailer depot fire at Preston Docks was quite a blaze.

9

A SCORCHING
WHITSUNTIDE

All the fun of the Whitsuntide Fair in the centre of Preston Market Square.

In 1963, the moveable feast of Pentecost was celebrated on Sunday 2 June and with it the traditional Whitsuntide Bank Holiday weekend was enjoyed. This practice continued until 1971, when the government replaced it with a fixed Spring Bank Holiday at the end of May.

On the Friday before the 1963 holiday, the *Lancashire Evening Post* headline declared 'Scorcher Whit Expected' and traffic will beat all records. The forecast was for a sunny and warm Whit weekend, with all the traditional delights in Preston or at the nearby seaside resorts expected.

By this time the traditional Whit Monday church processions had ceased, their demise coming at the beginning of the Second World War when attention turned to other matters. The Roman Catholics of Preston had marched since early Victorian days, with as many as 10,000 adults and children walking through the crowded streets. The Church of England procession that had begun in 1842 followed on in the afternoon, with once more up to 10,000 marching along carrying banners and waving to the crowds. The colour and pageantry never diminished down the years, and both faiths walked proudly on parade with the clergy and the congregations to delight the cheering crowds. One procession though did survive to parade once more in 1963, and that was the Loyal Orange parade that had first walked in 1837. That procession would usually take place between the other two, but in 1963 it took pride of place on Whit Monday afternoon. Glorious sunshine greeted the walkers, although a gusty wind made it difficult to control some of the banners. Starting from Moor Lane roundabout, the procession, led by two mounted policemen of the Lancashire Constabulary, took a tour of the town centre where large crowds greeted the walkers with enthusiasm. A figure depicting Prince William of Orange sat astride a grey mare following close behind, and he was flanked by flag bearers who waved them vigorously. In all, 3,000 men, women and children marched and, with several new tableaux on display and musical bands aplenty, the two hours provided plenty of entertainment.

That other great Whitsuntide tradition, the town centre fair, was up and running as usual. The trucks and lorries had rolled in and unloaded the fairground attractions in next to no time. Flying aeroplanes and boats, prancing horses galore, waltzers and dodgem cars went round and round. Novelty stalls and sideshows were plentiful, and stick three darts in a playing card meant a goldfish was yours. Not forgetting the shooting gallery, the coconut shy and the test of strength machine with the chance to impress your girl by ringing the bell.

The fairground was the place to be, particularly for the teenagers enjoying the Swinging Sixties era. It was all about the pop music in those days, and many a popular tune blared out from the fairground roundabouts. Top of the local hit parade at the time were the fast emerging Beatles with 'From Me To You', closely followed by Billy J. Kramer asking 'Do You Want To Know A Secret?' and heart-throb Cliff Richard's latest 'Lucky Lips' was at No. four in the chart.

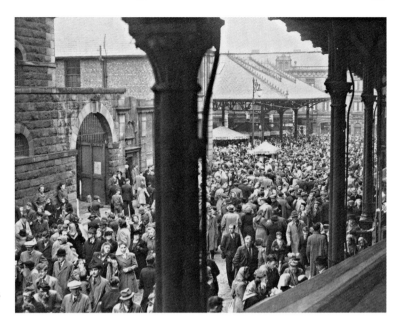

Crowds flocked to
the fair.

By this time, Preston only had six cinemas remaining, but they provided good holiday entertainment and attendances remained high. The Ritz and Odeon both showed Walt Disney films and Reg 'Mr Universe' Park was starring in *Hercules Conquers Atlantis* at the Palladium. Elvis Presley and Joan O'Brien were starring at the ABC cinema in *It Happened at the World's Fair* and the Empire's feature film was *Marco Polo*. As for the Continental cinema on Tunbridge Street, it was X-rated action as usual with the *Nudists Story* – strictly adults only there.

The Empress on Eldon Street had become a bingo hall, with eyes down every night and the chance of a £124 jackpot. The televisions rented from the likes of Radio Rentals, Telehire or Rediffusion were still transmitting in black and white, and only the BBC and ITV television companies had been born. Nonetheless, it was a lively weekend of viewing on both stations. *Juke Box Jury*, *Z Cars*, Perry Mason, Stanley Baxter and Jimmy Edwards led the way for the BBC and over on ITV it was *Thank Your Lucky Stars*, *Candid Camera*, *Cheyenne* and the *London Palladium* featuring Diana Dors. Well before midnight it was the *Epilogue*, the weather forecast and close down.

Much to the delight of Lancashire cricket fans, ITV transmitted the Roses match against Yorkshire during the three days. Sadly, the flickering images from Sheffield showed Lancashire in trouble, with Geoffrey Boycott scoring a century and Yorkshire winning by an innings. It was a happier weekend for Preston Cricket Club, with professional Ken Brothwood taking four wickets and scoring eighty runs, before a decent crowd at West Cliff as they ended Leyland Motors unbeaten record in the Northern Cricket League.

Most importantly, the holiday was to celebrate the religious festival and the churches didn't disappoint with ecclesiastic services to the Holy Spirit. With

space travel becoming topical, the Revd Tom Jenkinson preached at the Central Methodist church about 'Christians in Orbit'. At Emmanuel Parish church the Revd Fordham delivered a sermon about the 'Holy Spirit' and worshippers gathered at the North Road Pentecostal church.

For many, an eagerly awaited trip to the seaside was essential and the day trippers were not disappointed. Morecambe had a Whit Sunday with the temperature recorded as 77° Fahrenheit, and was so busy that the swimming pool doors were closed. Blackpool welcomed 125 trains and 1,200 coaches on one day alone, and the sands were awash with folk soaking up the sun. Southport had a record 21,000 cars parking on the sands over the weekend, and 10,500 deckchairs were hired out on the Sunday. Inevitably, add the seaside visitors to those who had been to the Lake District and, despite the new M6 motorway, it was a case of traffic grinding to a halt as the day trippers made their way home on Whit Monday. It had been a Whitsuntide to remember, and the *Lancashire Evening Post*'s scorching prediction had come true.

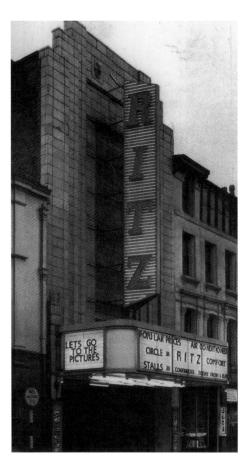 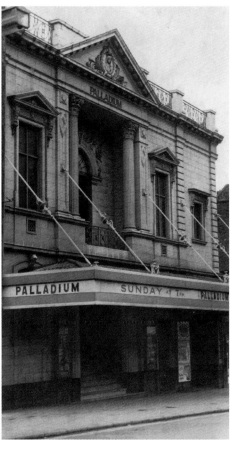

Across Church Street from each other, the Ritz and Palladium cinemas both provided holiday entertainment.

10

SIMPLY LEISURE AND PLEASURE

Leisure and pleasure was something that the people of the 1960s were beginning to buy into. With employment levels high, shorter working hours and young people with more disposable income, a leisure industry was developing.

Cinema audiences had been hit by television, but attempted to fight back with more attractive auditoriums, wider screens and, of course, technicolor – something the television did not yet have. The opening of the newly built ABC Cinema in 1959 had certainly given that industry a boost. Bingo was becoming popular, and many social clubs were being added to the local scene, be they church, political or sporting.

There was much excitement in mid-February 1963, when work was completed to transform the old Gaumont Cinema into a luxury modern entertainment centre costing £250,000. It meant the arrival of a new theatre, a restaurant and a ballroom. With a 1,200-seat cinema, a ballroom named the 'Top Rank' for 1,000 dancers and a full banqueting facility, it was designed to cater for all ages. In a first week of celebrations, the Rank Organisation hosted the mayor's charity ball and planned to demonstrate the 'Bossa Nova', the latest dance floor craze along with the limbo, the twist and the graceful beauty of the traditional ballroom dances.

The first film to be shown in the new Odeon Cinema was *On the Beat* starring Norman Wisdom. The Top Rank ballroom became the venue for the annual Northern Open Professional Ballroom Championship. Held in September, they provided an evening of glitter, glamour, colour and excitement with champions from around Europe attending and many local couples taking to the dance floor. The prize for the winners was £50.

Certainly, the Top Rank became a place for teenagers to frequent, and a number of leading pop groups of the era played at the venue with the dance floor packed. The music of The Hollies, Freddie & The Dreamers, The Searchers and the Rolling Stones, appearing in early November 1963, gave the place a flavour of the 1960s pop scene. With their unique R&B sound, the

Rolling Stones drew an audience of almost 1,000, the long-haired and tight trouser wearing five-man band included their recent hit 'Come On' and their latest single 'I Want To Be Your Man'. They were delighted with the screaming audience and the feeling was mutual. Their next date was the Cavern Club in Liverpool, following in the footsteps of The Beatles.

In late July 1966, the Merseys appeared at the Top Rank, and over 1,000 screaming teenagers had to be kept from reaching their idols by a human chain of stewards. In a pop star packed month ahead, Paul & Barry Ryan, The Cryin' Shames and The Creation were all booked to play the venue and next time crush barriers would be in place.

The Public Hall was still a popular venue, although its days were numbered. It still had the capacity to attract great entertainers as it had since 1882, when the Corn Exchange had become the Public Hall. In late October 1962, a relatively unknown pop group named The Beatles had been booked for a Preston Grasshoppers Rugby Club Dance. That night, with tickets priced at 6s, they shared the billing with Mike Berry and a group called The Outlaws, earning less than £20 for the gig. By the time of their second visit to the Public Hall, in mid-September 1963, the Beatles phenomena was well and truly underway, and 2,000 screaming fans paid as little as 4s 6d to watch them perform. That other iconic group, the Rolling Stones, appeared at the Public Hall in late January 1964, leaving lasting memories for many of Preston's teenagers.

Above: The Beatles appeared in Preston twice.

Inset: The Beatles were in town in 1962 and 1963 and their fans loved it.

Both the Public Hall and the Queen's Hall promoted professional boxing and wrestling contests during the decade, but they had mixed success in attracting crowds. A typical night of wrestling in March 1965 at the Public Hall saw a tag team match between the Monster & the Ghoul from the USA and the Campbell's from Scotland, and 24-stone Haystacks Coloon did battle with Duncan McRobert. The best seats costing 7s 6d. In 1966, a boxing event shown on ITV's *World of Sport* attracted an audience of only 150 spectators, leaving promoter Lawrence Lewis out of pocket.

In September 1968, the diversity of the role of the Public Hall was shown again when the thirtieth annual Ideal Home Exhibition took place within its walls. Star attraction was the popular entertainer Ken Dodd, and the theme for that year was home comfort and improvement.

Certainly strides were being made in the world of night-time entertainment, and by the summer of 1967 many were being attracted to the Flamingo Casino Club in Great Shaw Street, where you could spend an evening playing brag, blackjack or roulette if you fancied a flutter. The Club Royale on Market Street was another venue attracting those seeking night life. That July they had none other than the top comedy group The Bonzo Dog Do Dah Band appearing for a whole week. A year later they would release their hit single 'I'm The Urban Spaceman', produced by Paul McCartney no less.

Entertainment was certainly changing, as reflected in the July 1964 news that the Empire Theatre on Church Street was about to be transformed into a Super Bingo Palace. The Empire, first opened in 1911, had Norman Wisdom starring in *A Stitch in Time* as its final screening. In mid-August, on the opening night of the Empire Star Bingo, there was prize money of £300 and a personal appearance by Pat Phoenix, the actress who played Elsie Tanner in Coronation Street.

News was released in March 1968 of the intention to close the oldest of Preston's four surviving cinemas, the Palladium on Church Street, in early May. Star Associates, who owned the Palladium and the Ritz, planned to upgrade the Ritz and demolish the Palladium. The last night proved to be a lively one, as a gang of youths gathered inside and during the early part of the performance there was frequent shouting and whistling, with leather-clad teenagers running up and down the aisles. Eventually, twelve youths were ejected by the police and the audience settled down to watch *Hour of the Gun* the last film at the Palladium.

It was also a decade when youth clubs emerged to cater for the seemingly endless growth in teenagers. The Queen Mother was a welcome visitor to St Oswald's Youth Club in Harewood Road, Deepdale in November 1967. That November saw plans unveiled to build a new youth centre on the land occupied by the derelict church of St James on Avenham Lane, the town centre churches combining their efforts to raise the necessary £30,000.

At St Augustine's, the parishioners had the luxury of a social club and a youth club, the Parochial Centre in Herschell Street being opened in late February 1965 at a cost of £50,000. The youth club met three nights a week with table tennis and badminton on offer, and a fortnightly dance arranged

with local groups such as the Drovers, Sound 5 and Creeping Vines, hired to entertain.

In May 1968, teenagers rushed to join Preston's newest youth club, opened by St Joseph's at a cost of £30,000. Once 250 members had been enrolled the membership had to be reluctantly closed with a long waiting list. The popularity of the youth club was undeniable, and gave teenagers plenty of opportunity to take part in social and sporting pursuits.

On the sporting front, Preston has always had an active population and the 1960s was no exception. The amateur footballers of Preston loved a kick in the park on a Saturday afternoon. There was the Preston & District League, the Catholic Football League and the Sunday School League all flourishing with teams from offices, factories, shops, churches and schools having their 90 minutes of fun throughout the season. Besides the organised fixtures many a footballer would take part in a kick about whenever there was a football and wherever there was spare land and jumpers for goalposts. Eventually, in late 1967, a group of enthusiasts gathered at the Lamb Hotel in Church Street and made plans to introduce a Sunday football league. The league proper got underway in September 1968, with forty teams and four divisions.

The year 1969 was a significant one for the Preston Grasshoppers Rugby Union Football Club, who celebrated their centenary. At the time, the club were still playing at their Lea home and they reflected on a decade in which they had maintained a good standard in their club fixtures. To mark the centenary they arranged a fixture against the Old Cheltonians, a club with which they had links from the very early days. Traditionally, the Old Cheltonians were old boys of Cheltenham College, and although they did not have regular fixtures at this time, they drew a side together from all over the country to face the Grasshoppers, skippered by Mike Bowen.

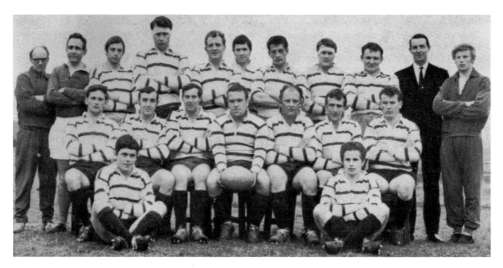

Preston Grasshoppers First XV in the 1968/69 season.

The fixture took place on the second Saturday of September before an enthusiastic crowd. Veteran wing forward Alan Marsh went over for the first try for the Grasshoppers and then after the visitors had missed with a penalty kick newcomer John Heritage crossed between the posts to increase the lead, with Thomas converting successfully. Despite some bright play from Old Cheltonians, the Grasshoppers kept a grip on the match and marked the occasion with a 30-5 victory. Both Heritage and David Worth finishing with two tries, and Tony Nelson and Mike Bowen also getting a try each.

During the summer months, the Preston & District Cricket League attracted the attention of locals. In the 1960s, it was a league with four divisions, with many of the sides playing on Moor Park. Teams such as English Electric, Goss, Emmanuel, St Joseph's, Frenchwood, St Peter's, Holme Slack, St Paul's, Jalgos, English Martyrs, St Walburge's, St Ignatius, St Cuthbert's, Ashton Baptist, Nomads, Nalgo and British Railways being joined by sides from farther afield, such as Longridge and Chipping. A typical Saturday afternoon in the summer would see numerous wickets pitched on Moor Park as teams battled for the points side by side.

One of the highlights each summer was the Turner Cup competition that was contested by all the local sides and culminated in a final played of an evening in Moor Park. Down the decades there had been many a swashbuckling encounter with crowds of up to 15,000 watching the action, but the final of June 1968 was one of the strangest. Frenchwood had batted first against British Railways and chalked up a far from impressive 111 all out. Enter Howard 'Buster' Page, a veteran of a number of finals in which he had always been on the losing side. A wicket in his first over, a hat-trick in his second over and then two more wickets in his third over left the opposition derailed. Ably supported by Andy Penswick, the Frenchwood side had the opposition on 5 runs for 9 wickets. A single and a sneaky boundary followed, before Page took the last wicket with the score on 10. The on-fire bowler finishing with figures of 5 overs, 3 maidens, 8 runs, and 8 wickets.

The decade was also a good one for Preston Cricket Club, who, playing at their West Cliff home, were in the Northern Premier Cricket League. From 1966, when they finished joint second, the team were challenging for the title.

A typical summer Saturday on Moor Park, with cricket in progress.

The 1967 season proved to be one of the most successful in their league history. In late August they were leaders of the league, but failure to beat Lancaster away on a day that they scored 162, and had the home side on 109 for 9 at the close, saw Blackpool join them at the top.

A week later, Blackpool visited West Cliff in the final fixture of the season. Blackpool started poorly, and struggled to 75 for 9 against the bowling of Higham and Hill. A defiant last wicket stand, in which Laycock scored 20 runs, left them 96 all out. Hill, with 5 for 51, was the bowler of the day for Preston. Preston in reply reached 26 without loss, with Brothwood and Horrex opening confidently. But then Clarkson took control for Blackpool, claiming 5 wickets in quick succession to leave Preston floundering on 36 for 5. Worse was to follow, as Laycock then dismissed the next two batsmen without them scoring and Preston were facing defeat. It was left to Gladwin and Dootson to stabilise the situation, and a stand of 38 runs, painstakingly gathered, saw them earn Preston a draw as they played out the final overs to finish on 78 for 8.

It meant a play off for the title the following Saturday, with Blackpool winning the toss for home advantage. Preston batted first and scored 188 for 3, with an opening stand of 144 between Ken Brothwood and Graham Horrex impressing the crowd. Blackpool made a brisk reply until they got to 67, when the loss of three quick wickets saw them adopt a more cautious approach. Despite using all the 40 overs allowed to them, Preston could not dislodge the last pair and Blackpool ended on 88 for 9 to draw the fixture. Geoff Hill almost spun Preston to victory with figures of 5 for 24. In a ceremony after the match, the team captains were jointly presented with the championship trophy and flag.

Crown Green bowling was another pursuit that flourished in the summer months with the Preston & District Amateur Bowling League attracting players of the highest standard. In 1967, the league consisted of nine divisions and many a midweek evening was spent with teams from clubs, pubs and factories battling for points. Frenchwood, Empire Services, Acregate Lane, Fishwick Ramblers, Vernon's, Parkfield, Deepdale, Courtaulds, Springfields, British Legion, Ribble Power, Central Conservatives, Dilworth & Carr, Goss, Lancashire Constabulary and Withy Trees were among the notable teams of the decade. The clubs took great pride in their bowling greens and many were of the highest quality.

Work was in full swing on Moor Park in February 1968 on the construction of a miniature golf course with over 1,050 yards and eighteen holes. It reflected the increased interest in the sport, and gave newcomers a chance to improve their skills before they joined one of the town's senior golf clubs. The Ashton & Lea, Fishwick Hall and Preston Golf Clubs all thrived during the decade.

The new municipal athletics track on London Road was beginning to have an impact on local athletes, and England international Mike Freary, the British 10,000-metre record holder, visited in May 1968. Taking on all comers, he ran 3 miles in 13 minutes 24.6 seconds – just a second outside the British record.

Swimming was a sport of the 1960s that many Preston folk indulged in. By this time, the most serious of swimmers were doing lengths of the large plunge at Saul Street baths. It was an activity that schoolchildren were encouraged to undertake, with weekly visits by most schools. If you managed to get your 10 yards certificate you were on your way, and a lifesavers certificate could follow. Many hardy folk had been brought up to go to the town's three open-air pools in the Waverley, Haslam and Moor Parks.

When it came to winter entertainment, the large swimming pool at the Saul Street baths was drained and covered with a wooden floor to create the Queen's Hall, a venue for dancing, theatre, boxing and wrestling. Consequently, on a January night in 1961, wrestlers such as the Zebra Kid, Reg Williams, Alf Cadman and Jose Arroyd fought before an enthusiastic audience.

The Preston Musical Comedy Society also performed there, and their last performance of the decade, on for six nights, was *My Fair Lady*. They, along with the Preston Drama Club, ensured that the live theatre productions performed in Preston down the centuries remained. With a ticket costing just 6d, you could have gone to see them perform *George & Margaret* in February 1968 without breaking the bank.

Throughout the decade, the leisure pursuits of young and old alike were catered for with folk encouraged to take part in team or community events. Preston, like all the other Lancashire towns, was swept along with the latest trends and fashions and there was a clamour to embrace the emerging entertainments. After a day of toil, the hours of leisure seemed well earned.

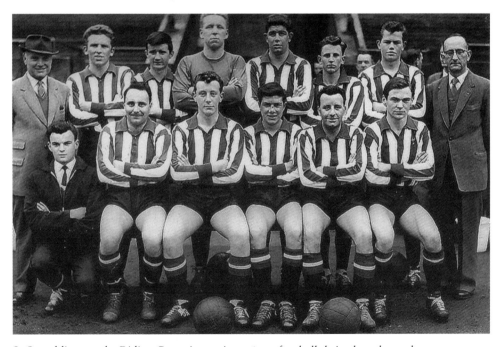

St Oswald's were the Riding Cup winners in 1960 as football thrived on the parks.

LAST FOOTBALL,
FULL TIME SCORES

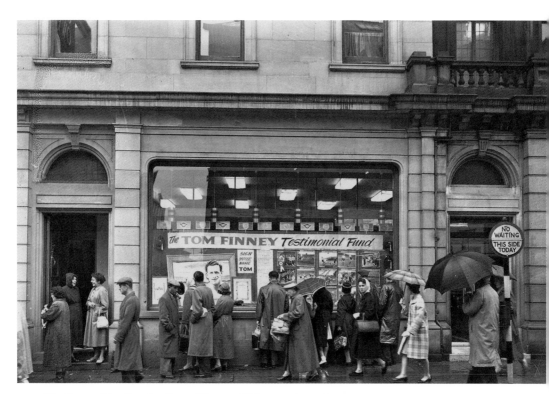

The *Lancashire Evening Post* offices on Fishergate in 1960.

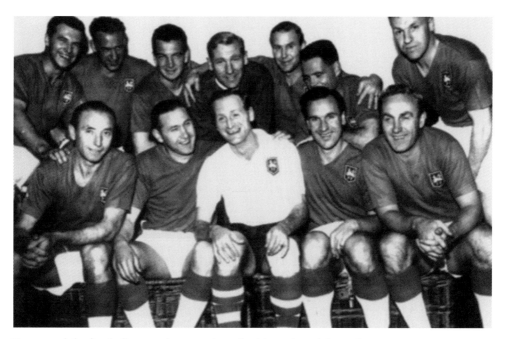

Finney and the football stars who turned out for his testimonial match.

In the 1960s, the people of Preston still had a great passion for football, as they had since the game began with Preston North End champions of the Football League for the first two seasons. It was a passion that could be enjoyed every Saturday teatime when the pink *Last Football* newspaper rolled of the printing presses at the *Lancashire Evening Post* offices in Fishergate.

The decade had begun with the retirement of Tom Finney, a decision that left Preston folk fearing for the club's future in the top flight, although the performance of the PNE youth team reaching the FA Youth Cup Final did give cause for optimism.

That first 'Finney-less' season started with three consecutive defeats, but a 2-0 home victory over Arsenal with Alan Spavin, Tony Singleton and Peter Thompson all making their league debut encouraged the supporters. A decent spell followed, including a run to the third round of the newly started Football League Cup, which ended with a 3-1 replay defeat away to Aston Villa. Unfortunately, another dip in form from December to February yielded no league victories and numerous failures to score. Things looked bleak until they went on a three-match winning run, defeating Fulham, Blackpool and Everton without conceding a goal. Another unbeaten four-match spell in March was ended by a 5-0 thrashing away to Tottenham Hotspur. That match seemed to affect their confidence, and after another dismal run they entertained Manchester United in their penultimate match of the season, desperate for points to avoid relegation.

Over 21,000 turned up at Deepdale, including a large following of United supporters, eager to see their side extend their winning run to three matches. With less than a quarter of an hour played, it was 2-0 to the Reds with Bobby Charlton and Maurice Setters scoring. North End fought back, a shot by Alex Alston was only partly cleared and Peter Thompson netted. Then, with 10 minutes to the break, Garbutt Richardson equalised with a header. Unfortunately, Setters was on the mark again for United, following a spell of pressure he put them 3-2 up at the interval. A heavy downpour at half-time made the conditions slippery in the second half, and although the young Thompson was causing problems for United they had long spells of possession, with Giles and Setters giving outstanding performances. Eventually, the skill of the visitors came through and Charlton scored his second goal to put them 4-2 ahead to clinch victory. As the PNE players returned to their dressing room, news that Newcastle had overcome Bolton Wanderers 4-1, and Blackpool had won 2-0 at Birmingham, meant relegation was a certainty.

That night's *Lancashire Evening Post*'s headline made grim reading, simply stating 'North End Are Doomed'. A week later, Newcastle joined them in the Second Division, despite a last day victory.

That summer brought an end to Cliff Britton's stint as manager, who resigned his post in late April. The former Burnley and Everton player had been the manager of PNE since August 1956. He became Hull City manager two months later, and held that post until November 1969.

Popular former North End player and trainer Jimmy Milne replaced him as manager. Milne had previous experience as a boss, having been in charge of non-League sides Wigan and Morecambe.

That summer saw the departure of crowd favourite Tommy Thompson, who joined Stoke City for £28,500, along with the signing of Alfie Biggs, a prolific goalscorer for Bristol Rovers, for a fee of £18,000. The 1961/62 season began with a surprise 4-1 defeat at Luton Town, and North End never looked like challenging for promotion. The arrival of Alex Dawson from Manchester United in late October 1961 gave them a boost, and led to a thrilling FA Cup run that saw them beat Watford, Weymouth and Liverpool, following a second replay. In the sixth round they drew Manchester United, and held them to a 0-0 score at Deepdale watched by over 37,000. At Old Trafford, on the following Wednesday in the replay, despite a goal from Alan Spavin, they went out of the cup by 2-1 before 63,000 spectators. The season ended with a tenth place finish in the Second Division table, with Alfie Biggs top scorer with twenty-two goals, including two against his old club.

The 1962/63 season saw relatively good home form and poor away form put them in trouble, and things only slightly improved after the departure of Alfie Biggs back to Bristol Rovers, and the arrival of Norbert Lawton, ex-Manchester United player, and Doug Holden, the left winger from Bolton. In a season extended due to the 'Big Freeze' of early 1963, it was the club's form in May that gave hope. Losing only one of their last six games and

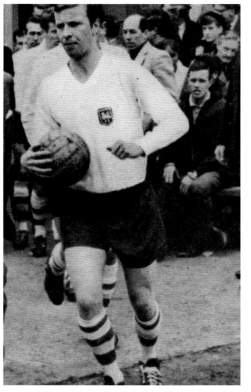

Above: A feature in *Last Football* titled 'What a Shocking Day'.

Left: Skipper Norbert Lawton arrived in 1962.

Below: The squad that got to Wembley in 1964.

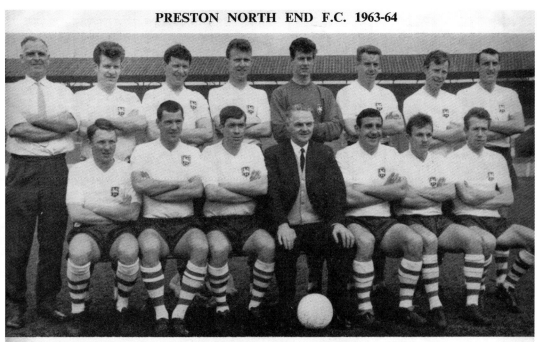

Back Row (*left to right*): W. CROOK (*Trainer*), G. ROSS, J. DONNELLY, J. SMITH, A. KELLY, T. SINGLETON, N. LAWTON (*Capt.*), I DAVIDSON
Front Row (*left to right*): D. WILSON, A. ASHWORTH, B. GODFREY, J. MILNE (*Manager*), A. DAWSON, A. SPAVIN, D. HOLDEN

defeating Derby County 1-0 at Deepdale in their final match saw them finish in seventeenth place.

It was the 1963/64 season that would bring renewed hope to Preston supporters. Involved in a three-way battle with Leeds United and Sunderland for the two promotion places, the strike partnership of new signing Alec Ashworth and Alex Dawson tormented many a defence. The team had a familiar look about it as the season progressed, and a Christmas double with 4–0 victories home and away against Cardiff City kept then on the promotion trail. They then embarked on an FA Cup run that would lead to a trip to Wembley in May.

Youngster Howard Kendall netted the winner against Notts Forest in a Deepdale replay and then Bolton Wanderers were beaten 2-1 in another Deepdale replay. Carlisle United were the next visitors, and they were beaten 1-0 thanks to an Alan Spavin goal. In the sixth round, a tricky trip to giant killers Oxford United was overcome with a 2-1 victory as Brian Godfrey and Alex Dawson scored. In the semi-final against Swansea Town, played at Villa Park in atrocious conditions, it was a rare goal from centre-half Tony Singleton that won the day. Wembley beckoned, but before that day they had a promotion challenge to maintain.

Unfortunately, despite winning four of the next five League games, it was the one 4-0 away defeat to rivals Sunderland that dented their hopes. Further defeats at Rotherham and Bury followed, and by the time Northampton visited Deepdale for the final League fixture, promotion had slipped from their grasp.

Dusting themselves down, they set off to Wembley to a FA Cup Final against West Ham full of optimism. With the seventeen-year-old Howard Kendall drafted into the side, following the late omission of Ian Davidson for disciplinary reasons, the Preston supporters made their way to London by road, rail and even aeroplane.

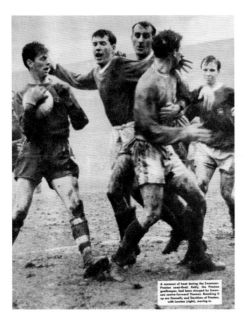

Above: A pint of milk a day.

Left: Semi-final action *vs*. Swansea town on a mud bath of a pitch.

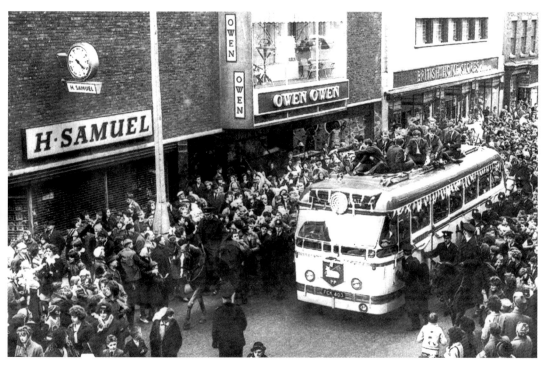

A welcome home along Fishergate for Preston North End.

Doug Holden and Alex Dawson both scored in the first half, in which they twice led to make it 2-1 at the interval. Geoff Hurst put West Ham level 7 minutes after the break, and the North End had goalkeeper Alan Kelly to thank for denying their opponents further goals. Just when it seemed extra time was inevitable, Brabrook got away on the right and his cross passed over the Preston defenders and in from the left came Boyce to head into the opposite corner, 3-2 to the Hammers.

There was relief for the claret-and-blue side and their skipper Bobby Moore, and despair for the lily whites after a tremendous performance. PNE had certainly produced some good football on the day, earning plaudits for a plucky performance. When they returned to Preston, a heroic performance received a historic reception, with Fishergate lined with supporters who cheered their valiant efforts.

During the 1964/65 season, Alex Dawson, who had scored thirty-six goals as they reached the FA Cup Final, scored another twenty-seven goals and, with Alec Ashworth injured for most of the season, Brian Godfrey chipped in with twenty-five goals. Despite their fire power, the team had a less than successful season, finishing mid-table and exiting both cups in the early rounds.

The 1965/66 season was another disappointing one in terms of promotion hopes, although it did have its moments. A League cup run to the fourth round ended with a miserable exit by 4-0 at Grimsby. The FA Cup though was to bring some magic moments. Victory away to Charlton Athletic was followed

by a home replay win over Bolton Wanderers, and a fifth-round tie at home to Tottenham Hotspur. Almost 37,000 filled Deepdale to see Ernie Hannigan score in his fourth successive tie, and Alex Dawson earn a 2-1 victory, a sixth round visit from Manchester United being their reward.

On the last Saturday in March 1966, a crowd of over 37,000 packed into Deepdale to witness the FA Cup quarter final against a star-studded Manchester United. In the event, there was drama both on and off the pitch. The collapse of a 45-foot long wall on the Spion Kop led to a number of casualties, with St John's Ambulance workers coming to the rescue as five of the injured ended up in hospital.

On the pitch, United looked a class outfit with a youthful George Best, Bobby Charlton and Denis Law in their attack. However, it was Preston who took the lead 5 minutes before the interval when Alex Dawson slotted the ball past Harry Gregg. Inspired by Best, the Reds hit back early in the second half to equalise through David Herd. Nonetheless, Preston withstood the United onslaught to earn a replay at Old Trafford. Alas, the visit to Manchester four days later saw the PNE cup hopes ended as they went down by 3-1 despite a brave effort.

For Preston North End, the last day of the 1965/66 season was to provide one of the most sensational results of their history. After their cup exploits, the PNE team had only managed a couple of victories in the Second Division, although they stayed clear of the relegation battle, entering the last day safe along with their visitors Cardiff City. Just over 10,000, the lowest League gate of the season, went to Deepdale that day in early May. They were treated for their loyalty in splendid fashion with North End 5-0 up at the interval, thanks to a hat-trick from Ernie Hannigan, as well as goals from Nobby Lawton and Brian Greenhalgh. Another hat-trick in the second half by Brian Godfrey, in the space of 5 minutes, put the North End 8-0 ahead and a further goal from Greenhalgh rounded things off at 9-0. The *Last Football* headline 'Goals Galore' reflected the North End performance. Welsh international Brian Godfrey ended the season as leading goalscorer with twenty goals to his name. Alex Dawson finished with eighteen goals. That season was also memorable for the introduction of a substitute to replace an injured player. In the fourth game of the season, away at Portsmouth, Frank Lee was brought on to replace Dave Wilson as PNE lost 4-1. On New Year's Day 1966, Brian Godfrey became the first North End substitute to score when he netted after replacing Alex Dawson in a 5-1 defeat at Coventry City.

In the summer of 1966, *Last Football* had a special edition on 30 July as England won the FIFA World Cup at Wembley. It had to go to press by five o'clock, so the final result, Germany 2 England 4, was in the late news column along with the 4.45 p.m. race result at Epsom won by Right Honourable Gentleman. The front page headline proclaiming 'It's 2-2 after 90 mins – Extra Time At Wembley'.

During the first half of the 1966/67 season, the PNE results had a frustrating consistency about them. It was a case of win at home, lose away. That was until

Carlisle came to Deepdale in December, and won 3-2, and then in their next fixture North End went to Northampton and won 5-1 to complete the double over the Cobblers. The second half of the campaign was equally unpredictable, and with a few draws thrown into the mix they finished the season below mid table. Once more it was Dawson back as leading scorer, with only thirteen goals, one more than Ernie Hannigan, reflecting the decline in performances.

For the first time in the 1967/68 season, North End faced a real threat to their place in the Second Division. The old familiar team was breaking up; Alex Dawson had departed for Bury, and the new faces included Archie Gemmill, Derek Temple, Ray Charnley and Willie Irvine. They found themselves battling with Rotherham and Plymouth to avoid the drop. In November 1967, the club decided to move team boss Jimmy Milne into the general manager role. Milney was replaced as team manager by Bobby Seith, a former Burnley and Dundee player and Glasgow Rangers coach, who would remain in charge for the rest of the decade.

The team struggled for a while under Seith, but eventually, with a strike force of Willie Irvine and Ray Charnley, they strung a few results together. A key victory came on Easter Saturday when they visited Blackburn Rovers. The only goal of the fixture came North End's way on the half hour mark, when ex-Burnley star Irvine stroked home a penalty. It was sweet revenge for a drubbing by 5-3 at Deepdale against Rovers in November. The *Last Football* headline that evening 'HAPPY EASTER! PNE GAIN REVENGE'. In the remaining weeks, they managed to string a few results together to finish four points ahead of relegated Rotherham United, managed by ex-PNE favourite Tommy Docherty. Eight goals during the season was enough to give Derek

PRESTON NORTH END 1968-69

Back row : A. Spavin, W. Cranston, A. Kelly, J. Smith, J. Ritchie.
Middle row : W. Crook (Trainer), D. Wilson, R. Heppolette, K. Knighton, G. Hawkins, J. McNab, A. Spark, Mr. R. Seith (Manager).
Front row : G. Ross, D. Temple, F. Lee, A. Gemmill, G. Lyall, W. Irvine, B. Patrick.

Temple the title of top scorer. At the season's end, Jimmy Milne moved into the chief scout role, leaving Seith in full control of first team matters.

In the 1968/69 season, the last full season of the decade, it was Northern Ireland international Willie Irvine who was top scorer with twenty goals – including fifteen in the League. Certainly, things were better than a year earlier, but the improvement only led to a mid-table finish. Only thirty-eight League goals highlighted the problem, with a cautious approach criticised in some quarters. The Football League Cup hopes ended in the Second Round with defeat at Crystal Palace. The FA Cup started brightly with a 3-0 victory at home to Notts Forest, and a Deepdale goalless draw against Chelsea, but a twice played replay at Stamford Bridge proved their undoing. Two goals behind in the first replay when the floodlights failed, North End took the lead through Gerry Ingham in the third encounter and only fell to two very late goals.

Now to the final season of the decade – 1969/70. PNE could still call on Alan Kelly, George Ross and Alan Spavin from their Cup Final team of 1964, along with Dave Wilson, who had returned from his time at Liverpool, but the side struggled. They began the season with a defeat at Charlton Athletic. One bright spot was a 4-1 home win in late August against Birmingham City, when Spavin, Irvine, Knighton and Lee all scored.

Unfortunately, they ended the decade with three straight defeats, the last one a 3-1 loss at home to Bolton Wanderers, with Archie Gemmill netting the final PNE goal of the decade watched by over 23,000 spectators.

Following the 1966/67 season, Preston North End introduced an official 'Player of the Year Award', and the winner was goalkeeper Alan Kelly, who also scooped the award in season 1967/68. The following season, the versatile veteran left-back and midfield player Jim McNab was a popular winner, and the decade ended with Bill Cranston, the former Blackpool player, winning the award for displays at centre half.

Reflecting on the decade, North End had certainly been on the decline, although they had moments to savour and the players had certainly entertained a Deepdale crowd. The crowd in turn had warmed to their new heroes such as Gemmill, Graham Hawkins, Ken Knighton, Gerry Ingham and Frank Lee.

THE DAY THE PUB
FELL DOWN

Preston has, down the centuries, never been short of public houses, despite the fact that that it was in the very heart of the city in Church Street that the first of Seven Men signed the historic pledge that led to the great national Temperance Movement, gathering pace under the guidance of Joseph Livesey.

Indeed, back in late Victorian days, there were 460 public houses and beer houses throughout the town making the saying 'one on every street corner' almost true. Yes, there were many a cotton workers' thirst to quench, but, even so, that number of licensed premises was impossible to sustain. By the time the soldiers returned from the Second World War, the inns and taverns in our town numbered a meagre 260.

Of course the 1960s was a period of redevelopment, and with the great slum clearance that took place it was inevitable that a number of public houses would disappear by the end of the decade. A far cry from the peak of Victorian days, but nonetheless there were still plenty of places to enjoy a beer or two.

During that period, the licensees were keen to keep hold of their licences and, consequently, when the Greyhound Hotel on London Road was set for improvement work, the landlord Eric Ratcliffe kept the public house open.

Work started early in November 1960, with plans for the roof and top floor to be removed and a wooden shell built up inside, along with a temporary bar to enable the premises to remain open in line with licensing laws. In the week beginning 14 November, the workmen started to knock down the structure and all seemed to go according to plan with visitors to the public house enjoying a pint in the vault.

Alas, on the afternoon of Wednesday 16 November, tragedy struck. Shortly before three o'clock the landlady, Eithne Ratcliffe, was dealing with the last orders. Fortunately, there were only a handful of customers, with Walter Pierpoint in his usual place at the end of the bar and Henry Marsden, Frederick Lawrenson and William Berry further along. Ironically, the conversation was about death, with the other men telling Pierpoint, a second-hand dealer, that

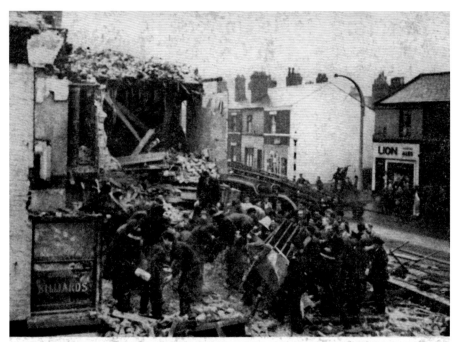

Clearing away rubble and wreckage at the Greyhound Hotel, Preston, yesterday in an attempt to rescue five people who were trapped after two interior walls had collapsed. One man was saved, but the other four were killed

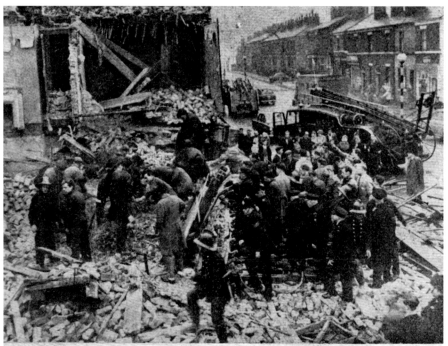

FIREMEN, policemen, and ambulancemen helped by passers-by dug feverishly in the r u b b l e and wreckage to rescue the trapped victims when two walls of the Greyhound Hotel in London-road, Preston, collapsed this afternoon. Four people were killed and a number injured.

Scenes of the rescue efforts from the rubble of the collapsed Greyhound.

trudging along the busy streets with his handcart would kill him and his reply was that he wasn't afraid to die as it happens to us all one day.

Suddenly, there were rumblings from within the structure, and the building collapsed with a crack like thunder. The street walls of the hotel fell outwards and masonry shot across London Road, with a huge cloud of dust mushrooming over the scene. Before the dust had settled, scores of people were clambering amid the wreckage, regardless of personal safety.

Within minutes, police, fire and ambulance services were at the scene and, led by fire chief Oliver Budd, firemen tunnelled their way through the masonry securing their path with hydraulic jacks. First to be brought out were Walter Pierpoint and Frederick Lawrenson, the former having escaped with multiple bruising and the latter being dead. Then, the lifeless bodies of Henry Marsden and William Berry were found and, after digging even further into the wreckage, the firemen discovered the body of the landlady Eithne Ratcliffe, who had been pinned down by ceiling joists. A surgeon who had tunnelled through with the firemen ascertained that she was also dead. An anxious search continued for some hours to ensure no one else was inside the crumbled remains, with the Preston Borough Police surgeon remaining on hand should any survivors be discovered.

Fortunately, nobody else had fallen victim of the tragedy, and by morning the awfulness of the situation was realised by the local community. Bowler hatted brewery officials from Boddington's, who had rushed to the scene the day before, remained on hand, and with fears for the safety of the structure it was decided to demolish the walls that remained.

Walter Pierpoint was on the mend and recounting the harrowing experience, while others recalled how fortunate they had been. One local stated that he had passed the public houses minutes before but, despite a thirst, an empty pocket had kept him away. Cornelius Robinson, of Thomas Street, told how he had been in the Greyhound only minutes before the collapse playing dominoes, and a motorist told how he had been heading down London Road when the building collapsed, scattering bricks across the road in front of his car.

When the inquest was opened on the following day, the distraught landlord Eric Ratcliffe told of how they had planned to serve beer throughout the alteration work while living at another address nearby. The brother of Henry Marsden, a driver's mate aged fifty, told how Henry had been off work with a leg injury and was just passing his time. A relative of William Berry, a retired hod carrier aged sixty-seven, spoke of William's liking for a drink in the Greyhound where his friends gathered, and the teenage son of victim Frederick Lawrenson told the gathering that his forty-nine-year-old father had been a ticket collector employed by British Rail, who had called in the public house after finishing his early shift that day.

It was a tragedy that Preston would not forget, and throughout the months spent demolishing and rebuilding the public house it was a constant reminder of the grief and heartache caused on that November day.

The rebuilt Greyhound Hotel, which is now closed.

When the new premises were opened, the landlord Eric Ratcliffe was once more behind the bar to greet the locals.

In March 1965, the tragedy was recalled at Manchester Assizes when Mr Ratcliffe, by then aged thirty-six, was awarded damages of £2,000, with costs, in respect to his wife's death. The award was against the builders and contractors who were carrying out the alterations. In fact, he spent almost thirty years serving Boddington's bitter before, on his retirement, he and his second wife Dorothy said goodbye to the Greyhound Hotel and its memories.

By the 1960s, the number of licensed premises had dropped considerably, with many of the old inns or taverns simply crumbling into eternity or being swept away in the name of progress. Although they no longer exist, many have still managed to remain part of local folklore to this day.

If we look at the sixties we can see that the inn was still an important part of the town and community. Where new estates were being erected, a public house or two was in the planning. Bearing in mind the progress of post-war years, with slum clearance, apartment blocks and road development, many significant changes took place within the licensed trade. North Road, ravaged by redevelopment, could no longer offer endless places of alcoholic refreshment, nor could Ribbleton Lane and New Hall Lane claim to have a public house on most street corners.

If we scan the list of public houses trading in Preston in 1968, it is obvious that the opening of new public houses was very much a rarity, although the Cross Keys was added to the Moor Lane landscape, the new Brunswick opened up in Avenham and the Brookfield Arms greeted those on the Brookfield

Estate. The ill-fated Lion Hotel was built on the Moor Nook estate, and on Lancaster Road in the newly developed area the Lancaster (later the Crystals) was opened. The days of the Harp Inn were numbered once the ring road was planned and the future of the Anglers Inn was looking bleak. The Port Admiral had a doomed look about it. Among those trading under another name at that time were the Grapes (now the Bears Paw), the Knowsley Hotel (now the Stanley Arms), and the Wagon and Horses (now the Tithebarn).

Many of the public houses attempted to encourage public spirit, and to this end they sponsored local football, cricket or bowling teams who carried their name and had weekly team meetings on their premises. Their most popular indulgence though was darts, and two local darts leagues were thriving in the Preston of 1963. The Lion Brewery, with many inns and taverns in the town, had a Preston Lion Darts League that consisted of thirty-nine teams split into three divisions. Teams from public houses such as the Angler's Inn, Cheethams, Springfields, Wellington Tavern, Kendal Castle, Exchange, Duke of Kent, Boatmans, Ship Inn and Paviours all gathered for midweek matches during the winter months. Not to be outdone, another league, known as the Preston Charity Darts League, was well established with twenty-eight teams split into two divisions. That league had such inns and taverns as the Queen Adelaide, Selbourne, Tanners Arms, Mitre Tavern, Stephensons Arms and Dr. Syntax in the fold.

In all, the total number of public houses, inns and taverns trading in 1968 was 172. The trend was certainly downwards, a fact that would have brought a smile to the face of Joseph Livesey – it had taken a while, but maybe the message was getting through.

The Brunswick, now closed, opened on the Avenham estate. The picture shows the pub *c.* 1990.

DOING THINGS POLITICALLY CORRECT

Battles for Preston North and South

Preston prides itself on its political history. Be it local or national, the people of Preston take their political ballot box duty seriously.

At the beginning of the 1960s, Preston had two parliamentary seats occupied by Conservative politicians – Alan Green representing the Preston South constituency with a majority of 3,019, and Julian Amery representing the voters of Preston North with a majority of 4,461 after the 1959 General Election.

In October 1964, the nation went to the polls once more and the Labour Party, under the leadership of Harold Wilson, gained a surprise victory over the Conservatives, led by Alec Douglas Home. The result of the poll gave Labour 317 seats, Conservatives 303 and the Liberals 9 seats in Westminster.

Nowhere was the action more dramatic than in the Preston constituencies. After a day of tension at the polls, the drama began to unfold just before midnight at the Preston South count. It was then that a recount was deemed necessary with Peter Mahon, the Labour candidate, posting a 151 vote margin over Alan Green. A few minutes later, a recount was also demanded for the Preston North seat with Labour hopeful, Russell Kerr, ahead of Julian Amery by just 8 votes.

Half an hour after midnight, the result of the Preston South vote was finally announced and Alan Green's nine-year stint as an MP was over. The announcement of a 380 vote majority for Peter Mahon was greeted with delight in the Labour camp.

In the Preston North constituency, things were still uncertain with an announcement at one o'clock in the morning that Julian Amery had a majority of ten votes. A further recount followed and this showed the Conservatives with an advantage of twelve votes. With such a slender margin, there was great debate over the number of spoiled papers among the 41,000 voters.

Mayor Fred Irvine 1961/62.

The counters then took a rest and refreshment break before embarking on the fourth count. It was after 3 o'clock in the morning that the fourth count was completed and there was much excitement as Julian Amery was declared the winner, with a fourteen vote advantage. He would be returned to Westminster for a fifth term, but faced life on the opposition benches.

Preston South		Preston North	
P. Mahon (Labour)	19,352	J. Amery (Conservative)	20,566
A. Green (Conservative)	19,004	R.W. Kerr (Labour)	20,552

The Labour party became somewhat frustrated with having to operate on such a small majority in Parliament, and in April 1966 they decided to go to the polls again, seeking a bigger margin. Interest was high in the two Preston seats, which were often seen as a barometer for the mood of the nation. Just twelve months earlier there had been the agony of the scrapping of the TSR2 and 2,000 job losses at the Preston Division of the British Aircraft Corporation. Although work had picked up lately, there was still reckoned to be some anti-Labour feeling, particularly with the government keen on purchasing the TSR2's rival aircraft, the F111, from the USA.

In Preston North, sitting candidate Julian Amery was hopeful of retaining his seat for the Tory party, while the Labour party pinned their hopes on Ron Atkins, aged forty-nine, a head of department at an Essex secondary modern school. Once more in Preston South it was a contest between Peter Mahon and Alan Green, a former financial secretary in the Treasury.

Preston lived up to its reputation of reflecting the mood of the country, with the voters clearly forgiving Labour for their locally unpopular actions during their first term in office. As Harold Wilson celebrated by being reconfirmed

as prime minister with an increased majority, the local Labour group also celebrated. Nationally, it read Labour 363, Conservative 253 and Liberals 12 seats.

There was triumph in Preston North for the Labour newcomer Ron Atkins, who ended Julian Amery's sixteen-year spell in Parliament. While in Preston South, Peter Mahon saw off the challenge of Alan Green by a much increased majority. No nail biting necessary at the 1966 election counts. As for Julian Amery, he was out of Parliament only a short time, being elected for Brighton Pavilion at a by-election.

Preston South		Preston North	
P. Mahon (Labour)	20,720	R.H. Atkins (Labour)	21,539
A. Green (Conservative)	17,931	J. Amery (Conservative)	19,121

For the remainder of the decade, Preston would have two Labour politicians representing them in Westminster.

The Battle for the Town Hall

On the local scene, the decade presented its own tense battles for control of Preston Town Hall. It started with the Labour Party holding a massive majority. At the time, the town council consisted of twelve aldermen elected by the councillors, and thirty-six councillors chosen by the electorate. Aldermen usually held the office for six years and a quarter of the councillors being up for election each year.

In the May 1960 elections, the Preston Tory party had plenty to cheer about, with gains in the St Matthew, Deepdale, Park and St John wards in the twelve seats contested. The town council had thirty-three Labour, fourteen Conservatives and a single Independent seat.

The trend towards the Conservatives continued in May 1961 when they gained three of twelve seats contested. The Labour party leader Alderman Arthur Wilson expressing his concerns at the progressive swing towards the Conservatives. The Tory dream of unseating the Labour Party that had ruled since 1949 was still on track.

Surprisingly, a year later, the swing to the Conservatives came to a halt with the twelve seats up for election showing only one change, with Independent candidate Thomas Dewhurst taking the Moorbrook seat from Labour, joining the former mayor John William Taylor on the back benches.

In May 1963, all twelve wards were contested by the Labour and Conservative groups, and it was a good day for Labour. The Conservatives' only successes being in their strongholds of Ashton and Avenham. They partly blamed their demise on the fact that the Liberals had joined the election arena and fielded candidates in Deepdale and St Matthews, leading to a split vote and a Labour double.

It was a position strengthened twelve months later by the Labour group, who increased their advantage by three seats, although, two Tory ladies did manage

to gain and retain important seats. Doris Dewhurst returned again in Tulketh, and Rita Lytton winning Ashton. The Mayor of Preston, Cyril Molyneux, was returned with the day's biggest majority in Ribbleton.

It seems that there was some anti-government feeling in the town in May 1965, following the axing of the TSR2 aircraft, with the Tories having a day to savour, topping the poll in all seven wards they contested. With Independent John William Taylor being elected to the Aldermanic bench, the Conservatives took his Ashton seat. Failure to contest the Central, Fishwick and Park wards left them wondering what might have been.

Twelve months later, the Conservatives continued their municipal revival with four more gains, capturing eight of the thirteen seats being contested. On a night of cliffhangers, six of the twelve wards were won with a majority of less than 100. In fact, all four Tory gains from Labour were in this category. On a sunny day in May, there was disappointment at a turnout of less than 43 per cent of voters. The Labour majority overall was down to just six seats, with their aldermen keeping them in power. With some changes ahead due to retiring aldermen in 1967, the Tories had high hopes.

After twenty-two years in the political wilderness, the Preston Conservatives celebrated the gaining of control of Preston town council in May 1967, following a landslide victory. In an astonishing series of results, they took seven of the eight Labour seats up for grabs. Only Cllr Cyril Molyneux was able to stem the tide as he scraped home in Ribbleton. It was a chance for Alderman Fred Grey to put the Tory plans into action. The shift in power left the town council with twenty-six Conservative, twenty Labour and two Independent seats.

The overall majority of four became twelve a month later following the alderman elections, where the Conservatives took four seats from Labour. The Conservatives then made a clean sweep of the four vacancies in Ashton, Avenham, Deepdale & Tulketh,

When the 'Blue Wind Blew' was the *Lancashire Evening Post* headline in May 1968 when the Conservatives won eleven of the thirteen seats contested. The only Labour success was that of Cllr Harold Parker, who beat an Independent challenger by 273 votes. Generally, it was a dismal turnout by the voters, and the Tories kept their grip with an overall majority of twenty.

The last local elections of the decade, in May 1969, confirmed the Tory popularity. This time it was victory in nine out of the ten seats contested. The only success for Labour was that of Robert Edward Butcher, who topped the poll in Ribbleton. The decade ended with the balance of power lying completely with the Conservatives with thirty-eight representatives including five aldermen.

Preston's First Citizens

The opportunity to become Mayor of Preston was one cherished by many of the municipal representatives, and throughout the 1960s the town had an interesting collection of first citizens. Throughout the year, they would

attend numerous civic functions and take an interest in all local matters. The traditional start of the mayoral year began in May.

The Mayors of Preston Through the 1960s

1960/61 – Wilfred Conroy
Sheffield born, he first joined the town council in 1946. A ballot box defeat in 1950 was followed by election for the Maudland ward, and subsequent success in the Fishwick ward through to 1958, when he was chosen to be an alderman. He earned his living running an office equipment business in Preston, and was a staunch Labour party politician. Living in retirement in Broughton he died in 1967, aged sixty-seven.

1961/62 – Fred Irvine
He entered the political arena in 1952 as the successful Tory candidate in the Avenham Ward. A resident of Glenluce Drive, Farringdon Park, he was continually selected at the elections that followed. Described as a boisterous and cheerful character, he was a popular councillor. Taken ill towards the end of 1963, he died in January 1964, aged fifty-nine, and the town council mourned his passing.

1962/63 – James Atkinson
Elected to the town council in 1950 in the Trinity ward, he served the Labour Party and the town as both councillor and alderman. A printer by trade, he lived in Lulworth Avenue, and was described as a man of high integrity, honour and humour. In March 1976, a newly acquired dredger was named after him. Sadly, a few weeks later, he died, aged sixty-five, after a period of decline in his health.

1963/64 – Cyril Evan Molyneux
He joined the town council in 1952 after being chosen by the voters of the Christ Church ward. A Preston postman, he lived in Selbourne Street and was an ardent trade unionist. Involved with town planning and housing, he played a key role in the redevelopment of Preston. His last Preston political battle was in 1967 when he retained his seat to deny the rampant Tories.

1964/65 – Joseph Lund
After two unsuccessful attempts, Joseph Lund won a seat on the town council in 1952 representing the electors of St John's ward. He was a resident of Albyn Bank Street and worked as an electrical fitter. A busy life in and out of the council chamber, he was a long-serving shop steward. He ended his days on the town council in 1976.

1965/66 – William Beckett
As leader of the Labour-controlled council, he was elected as Mayor of Preston

for the second time, having previously been the civic head in 1946/47. He was particularly involved with the finance, library and arts committees, and when the budget was on the agenda he gave many an informed speech. A resident of Broadgate, he retired from the council in 1973 and he died in 1981, aged eighty-three. In July 1964, Alderman William Beckett and former Alderman Frank Jamieson were made Honorary Freemen of Preston as a tribute to their service to the town.

1966/67 – Joseph Holden
Known as the top hat Tory, popular Conservative Joseph Holden was brought up in the Stoneygate area. He had served the Deepdale ward for over a decade. During the year, he revived some of the town's ancient customs. On Shrove Tuesday he carried out the old tradition of 'beating of the boundaries' of the old borough limits, before eating pancakes in the town hall. Later in the year he was seen wearing his top hat as he officially opened the annual Pot Fair.

1967/68 – Ernest Bunker
He arrived in Preston in 1950 having previously been a councillor in Tottenham. The Labour Party soon recognised his value and he attempted to gain election in 1951 and 1953. However, it was third time lucky in 1954 when he was selected by the voters in the Fishwick ward. Always outspoken with his views and beliefs, he was continually successful at the ballot box and eventually was elected to the Aldermanic bench.

1968/69 – Doris Dewhurst
A district nurse and midwife, she gained a place on the town council in 1961 for the Tulketh ward, after two earlier failures. A Conservative politician, she took a great interest in the education of the town, becoming a governor on a number of the town's college boards. She remained a prominent councillor until 1973, the year of her death.

1969/70 – John Brigg
He entered the Preston political scene in 1960 when elected by the Conservative voters to represent the Ashton ward. A director of a haulage firm, he was well respected in council circles. He lived in Ellerslie Road, Ashton and was continually backed by the Ashton voters until he was voted onto the Aldermanic bench in 1967. He died in March 1981 while returning from holiday.

It was a decade when the local political parties flexed their muscles and the politicians of Preston made crucial decisions that would shape the town for generations to come.

Familiar faces on the Preston political scene.
Harold Wilson with Mayor Joseph Lund.

Edward Heath addresses a political rally.

14

A JOLLY SIXTIES CHRISTMAS

A carol service was held on Christmas Eve. Christmas Day 1960 began with a bacon and egg breakfast, a lunch of roast beef and Christmas pudding followed. The day finished with tea consisting of iced cakes, trifle and coffee. Special Christmas Services held in the chapels were well attended, and in the evening films were shown and games were played. All this was in one place down Church Street, at Her Majesty's Pleasure, in Preston Prison. 'We tried to make it as much like home as possible,' remarked Maj. Geoffrey Nash, the prison governor responsible for the 700 prisoners.

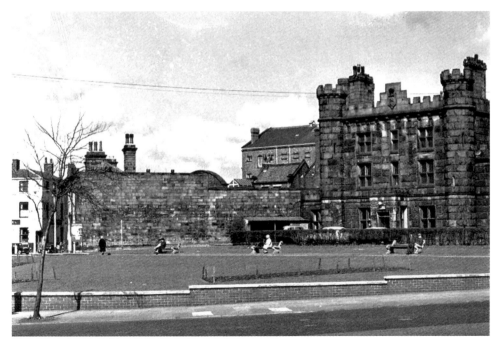

Those within the walls of Preston Prison had carols and Christmas pudding.

In the days before Christmas, the town's Roman Catholics had performed the Christmas Story nightly with a Nativity pageant on the Flag Market. The authentic production included a six-year-old Irish donkey named Danny, from Ballyclare, that carried the Holy Mother from a stable behind the Corporation Arms, followed by a group of witnesses. With Preston's list of churches numbering sixty-seven in 1960, there was no shortage of places to hear the Christmas message, be it from the pulpit of the parish church, the Bethel temple, the Unitarian chapel or from the Salvation Army. For the Roman Catholics, they had churches aplenty to visit for midnight Mass on Christmas Eve, and with Christmas Day on the Sunday the faithful seemed to double their efforts to pray. The Emmanuel parish church had a Holy Communion service in the morning and Evensong in the afternoon. The Baptist churches of Carey, Friargate and Ashton all had morning and evening services, and the Railway Mission on Corporation Street invited all to a Christmas celebration that evening.

Christmas 1960 was the year that Cliff Richard, along with the Shadows, topped the charts with 'I Love You', and Preston Dock was booming with a record revenue of £1 million. Timber, sulphur, coal and bananas all helped to boost trade. In keeping with tradition, all ships docked in the port were visited early on Christmas morning and the seaman were invited to the Sailor's Mission, where Christmas dinner was served.

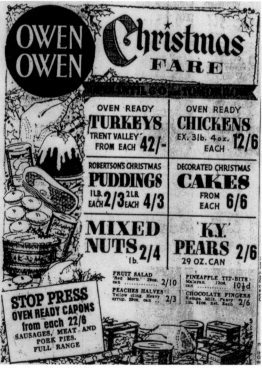

A young Cliff Richard was top of the pop charts in the 1960s.

Christmas treats on offer at Owen Owen, as advertised in 1960.

Certainly, Christmas was celebrated with much enthusiasm at the various institutions in the town. At the Preston Royal Infirmary, in Deepdale, the entertainment began five days before Christmas when the Excelsior Silver Band toured the wards. They were followed a couple of days later by St Paul's choir. The musical treat continued on Christmas Day when the Salvation Army band delighted patients with their tunes. Not to be outdone, the nurses themselves toured the hospital singing carols on Boxing Day.

The busiest couple on Christmas Day must have been the Mayor of Preston, Wilfred Conroy, and his wife, Constance. They were at Shepherd Street Mission, where thirty youngsters resided, at 8 o'clock on Christmas morning opening the doors and welcoming 500 less fortunate children of the town. Each child was given a toy and a bag containing fruit, sweets and chocolate to carry on a tradition begun over eighty years earlier. For the mayoral couple, visits to the various hospitals followed and they even called into the old Fulwood Workhouse to see the residents of the Civic Hostel. According to the mayor's wife, the highlight of it all was seeing two newly born Christmas babies at Sharoe Green Hospital and another one at the Preston Royal Infirmary.

Many a child growing up in Preston had hung a stocking up on Christmas Eve as they went to bed, in the hope that Santa Claus would be visiting to fill it and leave some presents by the side. The dolls, so cherished by little girls now, included the new generation of teenage fashion models like Barbie and her boyfriend Ken. Many a girl wanted a nurse's outfit to dress up like the stars of *Emergency Ward 10* and cowboy outfits were popular with the boys, who still yearned to dress as the Cisco Kid or Roy Rogers with a pistol in their holster. There was even a cattle drive game called Rawhide for those who watched the popular television series. Subbuteo Table Soccer was as popular as ever with the boys, and even a Junior Driver's set from Airfix, with steering wheel, gear stick and horn for those growing up in the motorway age. For the very lucky lad a pair of Maestro football boots, endorsed by Tom Finney, were delivered by Santa. A Scalextric set featuring racing cars of the period was challenging the traditional railway train set that lad and Dad had played with throughout the Christmas time of old, although this year Triang had introduced a Diesel Railway Set to challenge the steam locomotives – a sign of things to come. The Owen Owen store had them boxed and ready for 72s.

Teenagers were still twisting with the hula hoops craze and tape recorders, record players and vinyl singles were delightfully received. For dad, besides the socks and ties, the age of DIY was beginning to take shape, so a handy tool kit or an electric drill was bought by the wife wanting those odd jobs done. Magazines such as *Homemaker* and *Do It Yourself* gave food for thought, and local wives could buy their handyman a Stanley Tool Kit from Owen Owen for 37s. Many a husband with a fashion-conscious wife purchased her a pair of stiletto heels, or lacy nylon lingerie, or micro-mesh nylon stockings, or even popped into Tesco on Church Street to buy her a skirt for 10s or dress costing 15s.

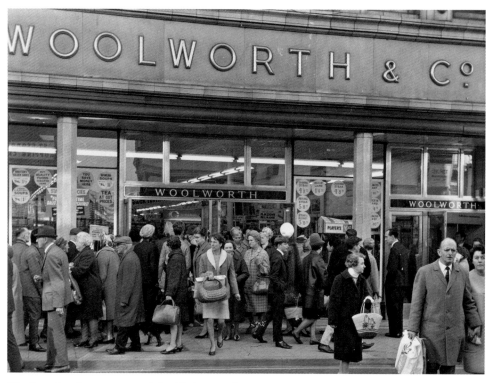

Woolworths always attracted the Christmas shoppers.

Nurses' uniforms, like *Emergency Ward 10*, were popular with the girls.

For the husband who got tools, the *Do It Yourself* magazine was popular.

As far as Christmas entertainment went, television was beginning to play a big part and both the BBC and ITV had midnight Mass to end their Christmas Eve schedules. On Christmas Day morning there were songs and carols galore. Many a family gathered around their television sets in the afternoon to listen to the Christmas message from Her Majesty the Queen. The stars certainly came out that night, with Spike Milligan, Tommy Steele, Jimmy Edwards and Harry Worth among a host of celebrities with seasonal offerings.

The local cinemas shut their doors on Christmas Day, but from Boxing Day there were double bills from early afternoon onward at the Ritz, Palladium, the Empire on Church Street and the Gaumont. The relatively new ABC on Fishergate celebrated their second Christmas with Leslie Phillips starring in *No Kidding* and Joan Crawford in *The Man Who Was Nobody*. For those who didn't want to venture into town, the Empress on Eldon Street, the Queen's in Acregate and the Carlton on Blackpool Road all had a tasty feature film on offer.

One sad occurrence on Christmas Day was the death of Beryl Formby aged fifty-nine, the wife of the popular entertainer George Formby who was loved by all cinemagoers of Lancashire. She had been suffering from ill health for over three years, and had been seriously unwell for four months. He was appearing in the pantomime *Aladdin* in Bristol, and drove through the night to her bedside. Sadly, she died before he could reach their Lytham promenade home called 'Beryldene'.

For local football followers, it was not a season to be jolly. Having to manage without Tom Finney after his retirement was proving difficult. North End faced a double clash, with Nottingham Forest visiting the City Ground on Christmas Eve to face a team managed by former Deepdale favourite Andrew Beattie. It turned out to be a busy afternoon for Preston goalkeeper Fred Else, who made some impressive saves, while the North End seemed to lack a cutting edge. The two goals that Forest scored in the first half sealed their 2-0 victory.

With North End at the bottom of the First Division, the Boxing Day return was seen as vital to their hopes. The team's poor form and a wet and windy afternoon resulted in a Boxing Day low, with an attendance of only 12,705. As usual at Christmas there were a few newly knitted North End scarves on display and bobble hats too, perfect for such a chilly day.

On this occasion the North End went behind after only 4 minutes, and despite chasing the game could not unlock the Forest defence. Young players Ross, Singleton, Alston, Wilson, Spavin and Peter Thompson would all play their part for PNE in the future, but their inexperience told in the end with a 1-0 defeat. It was six matches without a goal and relegation beckoned for Preston, who said farewell to the top flight at the end of April.

It was a better festive period for Preston Grasshoppers, who defeated Southport on Christmas Eve and then triumphed away to Fylde on Boxing Day. The Fylde clash was a struggle but they managed to hold on to a well-earned lead.

On reflection, it had been a merry enough Christmas, but certainly not memorable for its weather. It had been a case of showers and hailstorms ending

Tom Finney boots for boys.

on Boxing Day, with strong winds and a stormy night. Thankfully, Santa had crept into many a Preston home and filled those Christmas stockings with treats galore.

As for George Formby, the star of stage and screen, he got local tongues wagging in 1961. Rumours spread of his romantic relationship with Miss Pat Howson of Penwortham, aged thirty-six, a school teacher at St Wilfred's School in Preston. Following the death of his wife during the Christmas of 1960, the couple had been seen to be courting. In mid-February 1961, the engagement was announced between George Formby, who had been suffering from ill health in recent times, and the Preston schoolteacher.

Unfortunately, within days he suffered a severe coronary thrombosis and was rushed to St Joseph's Hospital in Mount Street, Preston. Miss Howson visited him daily for the next fortnight, and he appeared to be on the mend, so much so that he had asked his fiancé to buy a wedding ring so that they could be married on his release from hospital. Although he appeared to be recovering, and that familiar cheeky grin had returned to his face, he suffered a relapse and died in early March, shortly after Miss Howson had visited him. Preston was sad that George Formby, a star of many a fun packed movie, had passed away, and the couple's dream of moving into a fully furnished mansion in Lea to start their married life died with him.

His funeral attracted huge crowds, and thousands lined the route on his journey to Warrington cemetery and the family grave. There were a number of public remembrance services held for the comedian across Lancashire, and Preston held one at St Wilfred's church with a Requiem Mass attended by 250. Among the mourners were his fiancé, along with Mother Ignatius and Sister Winefride who had nursed him at the nearby St Joseph's Hospital in Mount Street during his final days. In March 1961, the *Lancashire Evening Post* reported that the Lancashire comedian had left the bulk of his fortune, estimated at £150,000, to his former fiancé Miss Howson, with bequests to his mother and to his valet Harry Scott, who would receive £5,000. The estate included his home at St Anne's, a yacht called Lady Beryl and a Georgian mansion at Lea, near Preston. The will was contested by the Formby family, and had never been fully resolved when Pat Howson died a decade later of cancer.

LEAVING OUR
EARTH BEHIND

On Monday 21 July 1969 the *Lancashire Evening Post* headline read, 'A Giant Leap For Mankind' and went on to describe the delight of American astronaut Neil Armstrong on becoming the first man to step on to the moon surface. Earlier that day, along with millions worldwide, the people of Preston had been glued to their black-and-white television sets as the historical drama unfolded.

Conveniently, the event occurred during the annual Preston holiday fortnight, and those that remained in the town had been treated to an enthralling adventure. Able to view the images flashed back to earth to our television sets, we were treated to the very best of coverage from the three television channels that existed in those days. Throughout the entire mission that had begun four days earlier, the BBC had James Burke and Patrick Moore presenting and, on ITV, David Frost and Alastair Burnett were describing matters.

The *Lancashire Evening Post* ensured local folk were up to date with a pull out entitled 'Moon Post' included for 5*d*. It included pen pictures of the three astronauts Neil Armstrong, Buzz Aldrin and Michael Collins and described the dangers that the Apollo 11 astronauts faced. It also recorded how the

Soviet Union had greeted news of the American success with a lukewarm acknowledgement in *Pravda* – their morning paper – where two paragraphs were sufficient to describe the event.

The *Lancashire Evening Post* was also happy to recall an article that had appeared in the *Lancashire Evening Post* in October 1952 under the headline, 'There May Be Men on the Moon in 25 Years' Time', written by Merrick Winn. It was at that time a brave prediction, considering man had not even scaled the summit of Everest, never mind touched down on the moon. Yet Winn had described the events to come with unerring accuracy, with talk of a towering rocket and helmeted space suits.

One Preston man who was to hit the national headlines on that day in July 1969 was bachelor David Threlfall. The twenty-six-year-old from Broadgate was whisked off to the television studios in London to be presented with a cheque for £10,000 from bookmakers William Hill. It was his reward for a £10 wager on the moon landing made a few years earlier at odds of 1,000:1.

Back on planet earth, in Preston, things were just continuing as normal. There was a walkout at Preston Docks after the sacking of a worker. At the Preston division of the British Aircraft Corporation they announced a record £10 million pounds worth of exports in the previous month. At Leyland Motors things were going well, with £1 million worth of orders for chassis for a number of buses, while the workers at the Courtaulds factory at Red Scar agreed to go back to normal working with the lifting of an overtime ban that had threatened production.

Local agricultural workers were also in dispute as they campaigned for a minimum wage of £16 for a forty-hour week. At the same time the future of the agricultural show piece, the Royal Lancashire Show, was under threat. Having been allowed to use the old Stanley Park Aerodrome for fifteen years, they now found that the municipal authorities were earmarking the area for a zoo. For the horse enthusiasts there was the Preston Holiday Horse Show taking place on Avenham Park.

If you were out shopping on moon landing day then the Maypole had cooked shoulder, lunch tongue and jellied veal, all for less than 2s a quarter pound, but the bargain of the week was apparently rhubarb at 1s a pound. At the Tesco store in Church Street they were giving away Green Shield Stamps with every purchase. The price of a large loaf was down by 3d and Typhoo tea was just 1s 4d for a quarter. While the Home & Colonial Store on Friargate Walk had Lancashire Cheese on offer at 2s per pound.

If you wanted to celebrate the moon landing with a night out, then the town's three cinemas were open with *Thunderball* on at the Ritz, the ABC Cinema showing Raquel Welch in *One Million Years BC* and the Odeon screening *Ring Of Bright Water* in glorious technicolor. For bingo addicts the old Carlton Cinema was promising three large cash jackpots with £100 to be won.

Of course, if you preferred to stay at home you could watch more of the lunar landings, along with *The Magic Roundabout* and *Z Cars* on BBC 1, or perhaps

see what was going on in *Coronation Street*, or what Bamber Gascoigne was asking in *University Challenge* on ITV. However, by midnight all the television channels had said goodnight, sleep well, God Bless.

As for the *Lancashire Evening Post*, before the month was over they were reporting on the next stage of space exploration with pictures from Mars sent back by the Mariner 6 spacecraft. Somehow, the world would forever seem a smaller place.

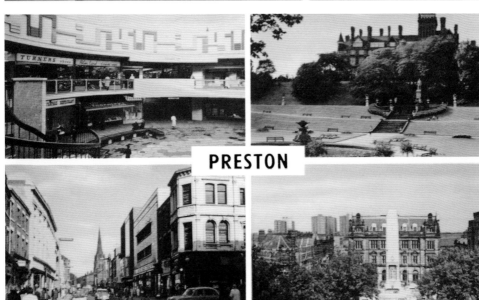

Above: Why was Fishergate so empty? Gone to the moon, maybe.

Below: Preston was Postcard proud.

The Enduring Legacy of the Sixties

The 1960s are remembered as a decade when youth led the way. The birth control pill and a sexually permissive society, the emergence of pop music, mods and rockers clashing, student protests, hippies smoking marijuana and a clamour for peace. Nudism, four-letter words, flower power and unisex; life would never be the same again.

It was the decade when the Paris fashions were eclipsed by Carnaby Street and the King's Road culture. Hemlines were getting thigh high, broad belts and bare bosoms common. The mini skirt was the height of fashion, but eventually the legs that had been bared were covered by the maxi skirt.

New gambling laws brought the casino, betting shops and bingo to the working man, who had always yearned to win the jackpot on football pools that were as popular as ever.

Changes in the law of the land brought an end to hanging. The law was changed in 1967 to allow homosexual relationships between consenting male adults and a year later the Abortion Act was introduced.

Crimes of the decade in the UK were the hideous murders committed by Ian Brady and Myra Hindley, the Great Train Robbery of August 1963 and, of course, the Kray's reign of terror in London finally ended. Early in the decade there was the John Profumo scandal with Christine Keeler in the news.

The tragic assassination of American President John F. Kennedy in 1963 and of his brother Robert five years later, along with the killing of Martin Luther King, led to great sadness.

World conflict seemed to be endless, despite the pleas for peace; man fought man in the Holy City of Jerusalem, in Vietnam's steaming jungles and on the snowy slopes of the Himalayas dividing India and China.

The shadow of the hydrogen bomb and the building of the Berlin Wall in 1961 was a reflection of East/West distrust. The Vietnam War rumbled on, with half a million USA troops still there active in 1969, and 300,000 American casualties by the end of the decade. There were skirmishes between Soviet and Chinese troops. An army coup toppled the Greek government. The Arabs and the Israelis fought on the borders, including a six-day war in 1967 and the blocking of the Suez Canal causing concern. Soviet missiles for Cuba led to another crisis. Finally though, the USA and the Soviet Union sat down to discuss their economically crippling arms race. The race to space kept us in awe throughout the decade, with Yuri Gagarin and Neil Armstrong becoming immortalised.

The British sporting heroes enthralled us all. Angela Mortimer won at Wimbledon; Bobby Moore lifted the World Cup; cricket had fiery Freddie Trueman; Grand Prix racing Clark, Hill, Surtees and Stewart were all champions and Henry Cooper boxed against the greatest.

In the years that followed, the decade was described as the sensational, the savage, the saucy and even the sexy sixties, and it left the world with memories that would linger for a lifetime.